SECRET
ST ANDREWS

Gregor Stewart

AMBERLEY

First published 2016

Amberley Publishing
The Hill, Stroud
Gloucestershire, GL5 4EP

www.amberley-books.com

Copyright © Gregor Stewart, 2016

The right of Gregor Stewart to be identified as the
Author of this work has been asserted in accordance
with the Copyrights, Designs and Patents Act 1988.

ISBN 978 1 4456 6186 5 (print)
ISBN 978 1 4456 6187 2 (ebook)

British Library Cataloguing in Publication Data.
A catalogue record for this book is available from the
British Library.

Typesetting by Amberley Publishing.
Printed in Great Britain.

Contents

Harbour

St Mary's
Church

Cathedral

Pends

St Leonards
School

Castle

Parliament I

St Salvators

North Street

Market Street

South Street

The Scores

Witch Hill

Witch Lake

Greyfriars
Garden

Bell Street

Hamilton
Grand

Royal &
Ancient

The Links

Parking

The Old
Course

Beach

Introduction

The town of St Andrews is probably best known as being the home of golf and for being the university city where Prince William and Kate Middleton met. Yet there is far more to St Andrews. It is where the bones of Andrew the Apostle, who became the patron saint of the country, first landed on Scottish soil. This led to St Andrews becoming the centre of Scottish religion. The cathedral ruins, described by Historic Environment Scotland as the 'remains of medieval Scotland's largest and most magnificent church', can still be explored today. The town also boasts the ruins of an impressive castle, once home to Scotland's leading bishop, and later archbishops, throughout the Middle Ages.

Although religion made the town rich, the Reformation almost destroyed it. The power struggle between the religious factions brought violence and persecutions and even put the town under siege. It is where the first Protestant martyr was burned at the stake and where an unknown number of men and women were burned as witches. St Andrews became the place where more killings in the name of religion took place than anywhere else in the country.

After the Reformation, the town struggled to survive until it was saved by the game of golf. Icons such as Tom Morris are remembered to this day and the Royal and Ancient Golf Club still has a significant role in setting the rules. The university once again thrived and the remains of the cathedral and the castle were saved.

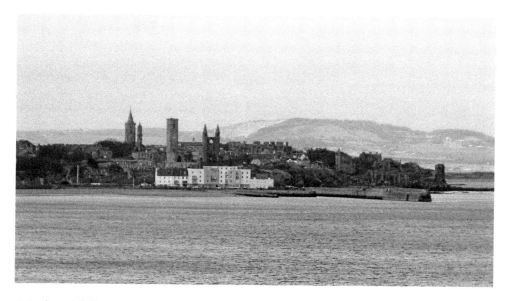

St Andrews' skyline.

St Andrews is a town with so much history that much of it has been forgotten. While writing this book, I have trawled through some of the oldest books about the town to bring together the history from lesser-known facts: how the town originated, the rise and fall of religion, the connection between the town and the Knights of St John, the origins of the university and how it survived the Reformation to become one of the best universities in the country today. Discover how the game of golf evolved and how, by replacing an archery competition, golf spread from its humble origins in St Andrews to be a worldwide sport. Read about Tom Morris and his son, Tommy, and how they dominated the game despite suffering terrible tragedies in their personal lives. The identity of one of the oldest ghosts is uncovered, with a true story that is more macabre than the fiction, and the work of Dean W. T. Linskill is explored, unearthing the truth behind the much-rumoured secret underground of the town.

Despite the wealth of history St Andrews has to offer, it has not yet given up all of its secrets, and some of the more recent discoveries, possibly confirming earlier theories, are examined.

I do hope you enjoy the book as much as I have enjoyed carrying out the research, bringing the information together and discovering unknown facts that are new for even the oldest residents of the town.

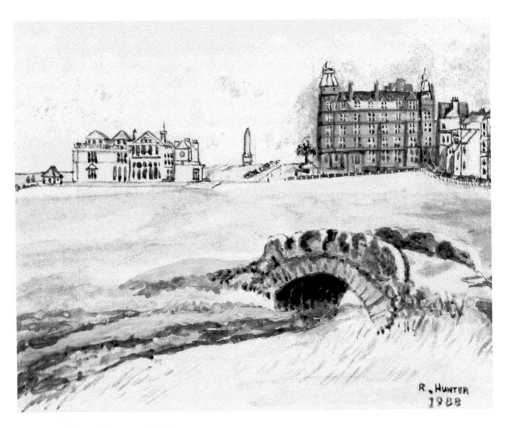

A painting by my late grandfather.

1. The Birth of the City of St Andrews

Although there is some variance in the tales surrounding the origin of St Andrews, the most widely believed version commences in the city of Patras, Greece. It was here that Andrew the Apostle was crucified around AD 70. Andrew was born in the town of Bethsaida, on the north-eastern shore of the Sea of Galilee, and is believed to have attended a synagogue school where he would have studied scripture, arithmetic and astronomy before following his father's footsteps by becoming a Galilean fisherman along with his brother Simon Peter (known as Peter). Andrew later met John the Baptist, and having heard his preaching, he became one of his disciples before meeting Jesus Christ. When John declared that Jesus was 'the Lamb of God', Andrew went on to spend a day with Jesus, before deciding to follow him and becoming the first Apostle of Christ.

Little is documented about where Andrew went to preach the gospel. He is mentioned in the Feeding of the Five Thousand and is thought to have travelled to Asia Minor (now mostly modern Turkey), Hungary and Russia before arriving in Greece, where he made his way to Patras. Upon hearing about Andrew's preaching and attempts to convert the people of the town to Christianity, the Roman governor, Aegeas, travelled to Patras where, in an attempt to crush the Christian movement, he enforced a legal requirement for the worship of the Roman gods, stating that sacrifices should be made to them. Rather

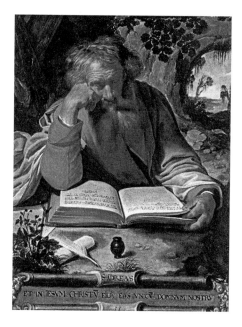

Artus Wolffort's painting of St Andrew.

than comply with the law, Andrew directly challenged Aegeas, declaring that there was only one true god in Heaven. Aegeas was understandably angered by Andrew's words, expressing that Andrew's teachings were based on superstition that had been abolished by Rome. He demanded that he ceased his preaching immediately or face execution. When Andrew refused, he was given the option to either be sacrificed to the Roman gods, which would be a quick death, or be crucified, a slow and agonising death. Andrew stated that as he preached the power of the cross, he did not fear death on the cross. Despite their conflicting religious beliefs, it does seem that Aegeas was willing to grant Andrew's wishes in death. He asked that he was not crucified in the same manner as Jesus, as he did not feel worthy of dying on the upright cross of Christ. Some versions state that Andrew was hung diagonally on the traditional cross, while the favoured version is that he was crucified on a Crux Decussata, the X-shaped cross more commonly known now as the Saltire, or the St Andrew's Cross. Although most depictions of the crucifixion show Andrew upright on the cross, early documents tell that he was hung upside down and he was tied to it, rather than being nailed to the cross. As a result, it took three days for Andrew to die; yet, despite his suffering, he remained of strong mind throughout and would preach the word of Christ to anyone who would listen.

Thanks to the intervention of a lady of influence named Maximela, who is said to have listened to the preaching of Andrew and adopted the Christian way, his body was embalmed and laid to rest in a tomb within Patras. His remains were left undisturbed until the fourth century, when a monk at Patras, known as Regulus (or Rule), is said to have had a vision, where an angel appeared to him, instructing him to remove some of the remains of Andrew and to hide them. Regulus was one of the monks responsible for the safekeeping of Andrew's tomb, which attracted pilgrims from all around, and so was able to remove some of the bones. Just a few days later, on the instruction of the Roman Emperor Constantius II, the remains of Andrew were moved to Constantinople, where

St Andrew with his cross.

they were laid to rest in the Holy Church of the Holy Apostles, a church constructed under the order of Constantine the Great, who is deemed to have been the first Christian Emperor of Rome.

Regulus kept the relics, which consisted of three fingers from the right hand, three toes, an arm bone, a tooth and a kneecap, hidden in a small chest that he had constructed to store them. A short while later, he had another vision in which the angel instructed him to gather a small, trusted crew and to immediately set sail from Greece with the relics of Andrew. He was to sail west, to the end of the earth, where he should establish a church dedicated to Andrew. Regulus did as instructed, and with a small crew of seventeen monks and three nuns, he left Patras on a voyage – he had no idea where or when it would end. They travelled across the Mediterranean Sea, through the Straits of Gibraltar, round the coasts of Spain and France, into the English Channel and then the North Sea where, after an estimated two years at sea, a violent storm drove them ashore and they were shipwrecked on the coast of Pictland (as Scotland was known then).

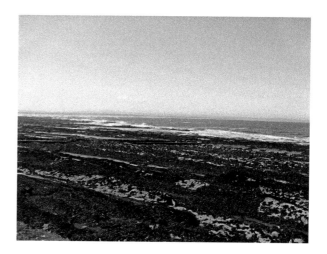

The coast of Scotland where St Regulus arrived.

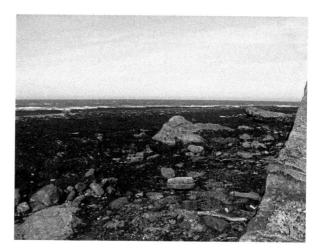

The rocks on which St Regulus was shipwrecked.

Seeking shelter from the storm, Regulus and the crew found a deep cave in the towering cliffs, situated between where the castle and harbour now exist, where they took the chest containing the relics.

At that time, the country was predominantly still under the rule of the Picts, who are often depicted as being primitive and barbaric in their way of life. The truth is, however, that the Picts did not keep written records, and so most accounts about them was written by those who arrived and sought to stamp out their religions, resulting in these accounts being far from favourable. The area that Regulus found himself was known as Muckross, meaning 'Land of the Boars', covered with dense forests and deep bogs. The woodlands were overrun with wild boar, of such size and ferocity that some of the first accounts compare them to the Erymanthian Boar, the capture of which was the fourth labour of Hercules. The land was ruled by the Pictish King Hergust from Abernethy, the capital of his kingdom, who upon hearing what had happened, travelled to Muckross to see for himself.

When King Hergust met with the pilgrims, it was clear from their destitute appearance that they offered no threat to his kingdom and so he granted them permission to tell their story of how they had come to arrive on these far shores.

The details of their quest and the new teachings they brought intrigued Hergust and he demanded that Regulus and his crew were to be given dry clothing and food. The king had a small hunting palace in the area and he instructed that the newcomers should be taken there where they could stay. Hergust continued to listen to the words of Regulus and soon gifted the hunting palace and all of the surrounding forested land to him, along with authority over those who lived within the area. A church was constructed nearby and devoted to St Andrew. His remains were placed there and Hergust adorned it with many gifts, including bowls, goblets, chalices, jugs and basins, all made from solid silver or gold. Some history books state that the church was St Rule's, of which only the steeple stands today; however, this church was not built until many centuries later.

Regulus continued with his preaching until his death thirty-two years after his arrival in the land now known as Scotland. Hergust had the area of Muckross renamed Kilrymont, meaning 'Church on the Royal Mount', and successive Pictish kings followed

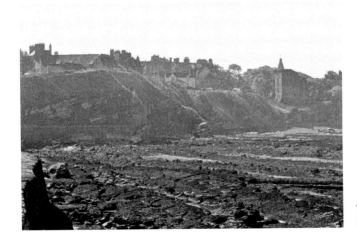

The cliffs where the
St Regulus sought shelter.

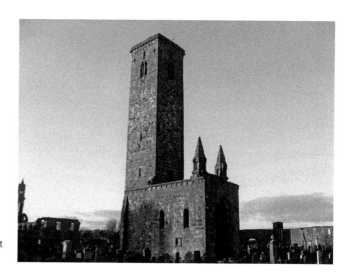

St Rule's Tower, the oldest part of the cathedral.

his example in adopting Christianity. Although the lands and property of the Christians had continuously grown, it was not until around 500 years after the arrival of Regulus that the Christian faith and the legend of St Andrew would be secured in Pictland.

The writing of Andrew of Wyntoun, a canon of St Andrews, tells that around the year 832, the Pictish King Oengus mac Fergusa II (also referred to as Onuist, Hungus or Angus) raided the lands of King Athelstan, the Saxon king who ruled Northumbria. As the Pictish forces returned with their ill-gotten goods, they were pursued by Athelstan and his forces that, unknown to the Picts, managed to overtake them. Around 4 miles north of the modern town of Haddington in East Lothian, Oengus found himself surrounded by the Saxons. Despite the Picts being joined by an army of Scots from the west coast, the enemy forces were far greater. With the light fading, Oengus knew that a battle was inevitable the following day and that the odds were heavily stacked against him. He prayed to the saints, particularly St Andrew, for victory, which he vowed, in return, he would gift one-tenth of his kingdom. As he slept that night, the legend tells that St Andrew appeared to him. Andrew told Oengus that his prayer had been heard by God and that his victory the following day would be quick and easy. To confirm this, the cross of St Andrew would appear in the sky. He also warned that after the battle, he should return quickly to his kingdom and fulfil his offering of land. When the king awoke the following morning, he gathered his army and revealed what he had been told and, as he did so, the clouds above parted to form a diagonal cross in the blue sky.

DID YOU KNOW?

St Andrews was first recognised as the patron saint of Scotland in 1320 at the signing of the Declaration of Arbroath.

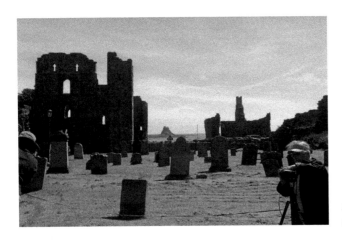

A Saltire forming in the sky above the Holy Isle.

Seeing this as a clear sign, his army was filled with confidence and inspiration and immediately attacked the Saxons with such ferocity that they soon had the upper hand against the larger army, which began to break apart. Fleeing Saxons were chased and hacked down as they ran, whereas those that remained were unable to withstand the attack and crumbled. With his soldiers lying around, dead or dying, Athelstan tried to escape but was captured. Oengus decapitated the Saxon king, had his head attached to a spear and displayed it on the island of Inchgarvie, which today is almost directly below the Forth Rail Bridge. The village of Athelstaneford now stands close to the battlefield.

Oengus quickly travelled to the Church of St Andrews, where it is said an old 'Register of St Andrews' stated that the area of land gifted to the church extended from the River Forth to the River Tay, and then to a line drawn from Largo, through Cupar and on to Haughton (near Balmerino). To signify his gratitude, the king first approached the relics of Andrew, dropped to his knees and kissed them, before placing a piece of turf from the land that was to be gifted on the altar of the church. This act was witnessed by the noble families of the time, along with other members of the royal family who were required to make a solemn oath that, from that day forward, they would display the cross of St Andrew on their banners and standards. Oengus would go on to command that his army were all to wear the symbol or further adorn the church with more gifts, including a gold figure of Christ, along with twelve silver figures, one of each of the twelve Apostles, and a gold box in which the relics of Andrew were placed. Possibly, the most important act of Oengus was he declared that the men of the church were to be exempt from the jurisdiction of the civil courts. This order would have severe ramifications not only for the town but also for the whole country.

The country now known as Scotland was predominantly occupied by the Kingdom of the Picts and the Kingdom of the Scots. The two kingdoms lived in relative peace after their decisive victory against the Saxons. That would all change when, following the death of both sons of Oengus (the younger son murdered his elder brother to claim the crown and married his dead brother's wife, only for her to kill him as he slept in revenge for murdering her husband) with no direct heir, a man named Feredeth, who is said to have held great authority within the noble families, was selected as king. Feredeth, it seems, did not share his predecessors' admiration for the church at St Andrews and took much

of its wealth for himself. A series of incidents followed that eventually led to war and the Picts being wiped out by the Scots In those superstitious times, many believed that the downfall of the Picts was as a direct result of the disrespect King Feredeth showed at the Church of St Andrews. The country was unified under King Kenneth I, who had blood claims to both the thrones, in time to face the greater threat of the Viking attacks. The region now known as Fife was placed under the control of one of King Kenneth's chief supporters, Fifus Duffus, who moved the seat of his government from Abernethy to Kilrymont, which he renamed St Andrews. Thus the town of St Andrews was born.

DID YOU KNOW?

Scotland is the only country out of the four that make up the United Kingdom which has an Apostle as a patron saint. St Andrew is also the patron saint of Greece, Russia, Romania and Barbados. His patronage also extends to singers, fishmongers, gout, sore throats, old maids, spinsters and women wishing to become mothers.

2. The Role of Religion

Although religion would go on to shape the town of St Andrews as we know it today, the religious powerhouse that was being created in St Andrews would be influential in the shaping of the rest of the country. The first Christian sect in Scotland was known as the Culdees and worshiped what has been referred to as a simpler, truer form of Christianity. In around 1123, they constructed St Rule's Church (St Rule being an alternative name for St Regulus), which included an impressive 33-metre-high tower that was intended to act as a beacon for pilgrims travelling to St Andrews. Unfortunately, they were not to enjoy the use of their new church for long. Religion in Scotland was moving towards the Catholic faith, and both King Alexander I and his son, King David I, were determined to create a religious house of the Augustinian Order in St Andrews. The Church of St Regulus was chosen for that purpose and the relics of St Andrew were moved there. The Culdees were forced to move to a nearby church on the easterly cliffs overlooking St Andrews Bay, known as the Church of St Mary on the Rock. The origin of this name is unclear, although seventeenth-century writers tell that the original Celtic monastery, which is known to have existed as far back as the middle of the eighth century, was in fact built on a rocky outcrop that was beyond the end of the current pier. Although the sea now covers this area with every high tide due to coastal erosion, it is still known as Lady Craig's Rock.

Although the Culdees, who were generally married men with the eldest son taking their father's place, continued to hold the Church of St Mary for several hundred years with

Lady Craig's Rock, partially covered by the sea.

just one bishop and twelve priests, the same could not be said for St Rule's Church. The Bishop of St Andrews at the time was Bishop Robert, and to accommodate the growing number of priests and worshipers, the original church had to be extended to both the east and the west, with additional buildings being constructed to the south. David is reported to have visited St Andrews soon after the work commenced, keen to see the priory he and his father had planned for established in the town. Following this, Bishop Robert was able to use his influence on the king to grant a royal charter to St Andrews.

Just before the consecration of Bishop Robert, an important but forgotten event took place. Alexander I granted a valuable and well-known district of land to the Church of St Andrew. This section of land, which extended from St Andrews to the current day village of Boarhills, had previously been removed from the church for an undisclosed reason, yet Alexander offered to restore the rights of the church on the land, on the condition that religion was fixed as ordained by him. The land generated considerable revenue, but there was one issue – it was the territory of a massive wild boar that had been responsible for killing cattle and men over the years. Several huntsmen had tried, and failed, to hunt down and kill the boar, which lead to the area being known as Boar's Chace. Eventually, a group of hunters were sent out who were successful in capturing and killing the boar. The official coat of arms of St Andrews shows the image of St Andrew holding his cross on one side and a large boar chained to an oak tree on the other. Early historical reports indicate that it was the capture of the boar at Boar's Chace that inspired the image of the boar.

In 1159, by which time Bishop Arnold had succeeded Bishop Robert, it was evident that even with the additions, St Rule's Church was simply too small, and the decision was made to create a great church. With the Bishop of St Andrews also holding the position of principal bishop of Scotland and considerable wealth and honours being granted to the

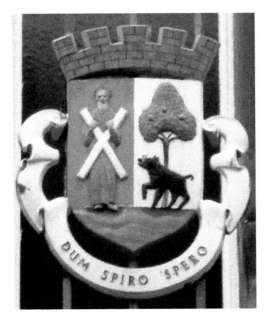

The coat of arms of St Andrews.

new church by royal charter, the new building would be required to represent St Andrews place as the centre of religion in Scotland. Work started on the new cathedral between 1160 and 1162, and it took 150 years to complete. The construction work did not go as smoothly as planned; in 1270, a storm rolled in from the sea and the strong winds blew down the west end of the cathedral. It was rebuilt, albeit in a slightly adjusted position, however, taking into account the scale of the building and the exposed location, it could be argued that it was fortunate further damage did not occur over the decades of constructions.

The resultant cruciform building measures approximately 120 metres long and approximately 52 metres wide, which makes it the largest church ever built in Scotland. The cathedral was dedicated in the presence of King Robert I (better known now as Robert the Bruce) in July 1318 and with the surrounding ground designated to be used as a cemetery and a tall defensive wall with watchtowers enclosing the location, the building was a most impressive sight. With the cathedral set to become the headquarters for the Scottish Church, a suitably prestigious residence for the bishop was also required. Bishop Roger (1189–1202) initiated the construction of St Andrews Castle; its remote position to the cathedral and defensive walls is an indication of these dangerous times. With these prominent buildings bringing workers and pilgrims to the area, the town started to grow around them.

DID YOU KNOW?

The castle once had a bowling green beside it. Sadly, this was lost, along with a significant portion of the castle, due to coastal erosion.

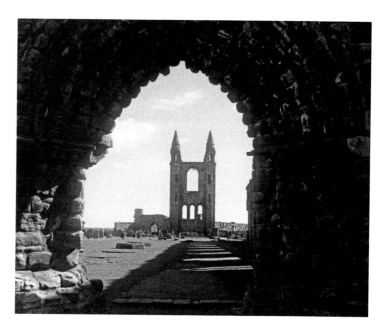

The cathedral entrance. The far tower is the rear of the building.

Although many history books give the impression that the priors of the Culdees and the cathedral lived side by side in harmony, earlier records tell a different story. The disputes began before construction of the cathedral had started. The priors of the Culdees had already been excluded from carrying out religious duties in England due to them being married men, and so not deemed suitable. In an attempt to further erode the Culdees, a papal bull issued by Pope Innocent II prevented the priors of the Culdees church from electing their own bishop, as they had done since the sect was established, and instead passed this authority to the priors and cannons of the Church of St Andrew. The dispute that followed went all the way up to King David who, in an attempt to resolve matters, ruled that a fixed number of Culdee priors should be allowed to vote along with the priors and cannons of the Church of St Andrew. To overcome this, a mandate was issued by the pope that excluded any prior of the Culdees from entering the Church of St Andrew. The command issued by King Oengus, which stated men of the Church of St Andrew were to be exempt from the jurisdiction of the civil courts, effectively meant they could now act against the will of the king.

Having been forced from their own church, they found themselves on the outside of the defensive wall being built around the great cathedral, so the Culdees seized an opportunity to regain their rightful role when the heir to the throne was being disputed between Robert the Bruce and John Balliol. William de Lamberton had just been appointed as the Bishop of St Andrews, which the priors of the Culdees opposed. William Cunninghame, the provost of the Culdees, took their appeal directly to Rome, and representatives from the priors of the Culdees and Church of St Andrew were asked to debate their rights. In June 1298, Pope Boniface VIII ruled in favour of the Church of St Andrews, an act that left the Culdees further weakened and little more is mentioned about them in St Andrews.

The cathedral and the castle of St Andrews have been involved in some pivotal events in Scottish history. After defeating the forces of William Wallace at the Battle of Falkirk on 22 July 1298, Edward I of England, the Hammer of the Scots, summoned the Scottish

The remains of the Culdees church.

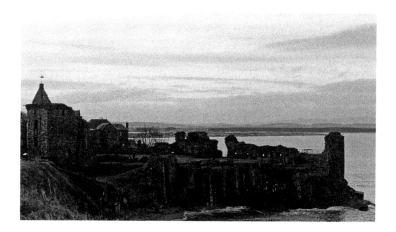

St Andrews Castle.

parliament to St Andrews where he demanded that every member must swear allegiance to him as their lawful sovereign. Eleven years later, Robert the Bruce also summoned the Scottish parliament to St Andrews to recognise his entitlement to the crown of Scotland. During the First War of Scottish Independence, fought against England between 1296 and 1328, the castle was extensively damaged and the lead stripped from the part-built roof of the cathedral by the English forces. In 1336, during the Second War of Scottish Independence with England, Edward III's forces successfully took many castles in southern and central Scotland, including St Andrews. A garrison was placed in the castle, who tried to take control of the town when Edward returned to England. Sir Andrew Murray, Lord of Bothwell, along with the earls of March and Fife, laid siege to the castle on 7 February 1337 and, in less than three weeks, they had taken control of both the castle and the town. To achieve this, they are reported to have used machinery capable of hurling stones weighing up to 200 pounds at the castle (this may have been a form of trebuchet, a medieval catapult used to throw massive boulders). Once the castle had been taken, they continued to cause further damage to ensure that the castle could not again be used as a stronghold by the enemy.

It is perhaps difficult to imagine enemy forces spending so much time and resources attacking the popular tourist town of St Andrews we know today, but such action is a clear sign of the importance of the town at the time.

The Knights of St John

The Order of the Knights of St John, or the Knights Hospitallers, can be traced back to the first century. As the year 1000 approached, there was a belief that the Second Coming of Christ would occur soon, drawing pilgrims from all over the world to the holy places of Palestine. This continue for many years and with ever-increasing numbers arriving with nothing more than the clothes they wore and what little they could carry, in the year 1023, a group of merchants from the Duchy of Amalfi in Italy obtained permission to establish a hospital in Jerusalem to offer free medical treatment for the poor and sick Latin pilgrims. To show their gratitude, some of those treated stayed behind to help care for future arrivals, whereas those returning talked of the hospital and it soon started to

attract both more travellers and donations to assist with the running costs. As it grew, more organisation was required, and the Order of the Knights of St John was created.

At the start of the Crusades in the eleventh century, the hospital treated injured soldiers, which in turn attracted further gifts and donations from the wealthier crusaders, keen to show their gratefulness, while the authorities in Jerusalem provided those involved with the hospital a black cloak, with a white, eight-pointed star on it, to wear (now better known as the Maltese Cross). In 1113, Pope Paschal II issued a papal bull formally acknowledging the institution, and in 1118, the knights took an oath to become militant defenders of the cause of the cross. Sometime later, the more famous Knights Templar were created, with the main difference being they were the first military order, assigned to guard the roads and provide safe travel for the pilgrims. Due to their reputation, this organisation grew rapidly in both size and wealth. They became established in many different countries, including Scotland, after Edward I granted them land.

When the Crusades were lost, the demand for their services declined, and with rumours of corruption, the Order fell as quickly as it had risen. On 6 October 1309, Edward II commanded John De Segrave, whom he had appointed as Guardian of Scotland, to arrest all Templars still at large in Scotland. The Templars had several properties in St Andrews, and ownership of these later passed to the Knights of St John, who were still viewed favourably. Very little is known about the early establishment of these properties or their use, with the first document relating to them believed to be in a charter issued by Malcolm IV of Scotland in 1160 relating to the Canons of St Andrews Cathedral, in which two of the witnesses are named as 'Richard of the Hospital of Jerusalem' and 'Robert, Brother of the Temple'. The information is expanded a little by Bishop Richard, Malcolm's chaplain, who states that the Canons are being granted a tenement building 'next to the Brothers of the Hospital of Jerusalem in North Street'.

One of the sites of the properties of the Knights of St John.

In the 1912 book *The Knights of St John* by David Henry, along with other medieval institutions and their buildings in St Andrews, it states that the Knights in fact owned two properties in North Street; one on the south side and one on the north side. From the details of these properties, they were substantial. The one on the south side occupied the site where the properties numbered 68 to 72 North Street now stand extended all the way to Market Street, where Nos 45–53 are located. On the north side of the street, the building extended from where Nos 47 and 49 now exist, to the Swallowgate, the street that preceded The Scores. The same book describes a third, larger property that was owned by the Knights. This is described to have extended from Market Street to the north, Baxters Wynd (now Bakers Wynd) to the east, South Street to the south and a boundary wall that ran from the current property at No. 79 South Street to No. 54 Market Street to the west – the area was approximately 73 metres long and 48 metres wide, almost 1 acre in total. It is estimated that, in the twelfth century, these three properties marked the most westerly edge of St Andrews within the city walls, but as the town extended westwards, they became more central in the town centre.

Information on the use of the properties is scant. It is believed that the Knights will have occasionally stayed in the dwellings, although the majority were tenanted out, allowing them to capitalise on their inheritance. The Reformation would ultimately lead to the end of the Order of the Knights of St John in Scotland, which was a Catholic organisation.

DID YOU KNOW?

St Andrews cathedral was not only the largest church in the country but also the largest building for over 600 years.

3. The University

Formed between 1410 and 1413 and founded in 1413, the University of St Andrews is the oldest in Scotland, and the third oldest university in the English-speaking world, with only the universities of Oxford and Cambridge predating it. Prior to its formation, many of the scholars in Scotland had travelled to England or mainland Europe, most commonly Paris, to gain their education, limiting the options to only the wealthy or privileged. In addition, what became known as the Hundred Years War had been ongoing since 1337 between England and France. With rivalries escalating in 1399, travelling to either country had become increasingly difficult.

The Bishop of St Andrews at the time was Henry Wardlaw, who had himself been educated at both Oxford and Paris. He foresaw the long-term effect of the difficulties in obtaining an education, particularly in religious learning. Around May 1410, suitably experienced clergymen began giving lectures to prospective students, and on 28 February 1412, Bishop Wardlaw issued a Charter of Incorporation and Privileges, making the fledgling university an official corporate body with the aim to deliver studies in divine and human law, medicine and the liberal arts and faculties. Clergymen holding permanent positions within the church were granted leave to either teach or study and anyone involved in the university was granted special privileges, which were extended to outside bodies including stationers and parchment makers, and their families. These privileges excluded the university members from carrying out guard duty at the castle and from paying income tax or capital levies, and the prior and archdeacon, along with Bishop Wardlaw, imposed regulations on the price charged for necessities such as bread and ale to prevent the townsfolk from overcharging visiting students (it is estimated that towards the end of the fifteenth century, there were between sixty and seventy bakers and around the same number of brewers in the town).

An application was made to Pope Benedict XIII and on 28 August 1413, he issued a papal bull of foundation for a university of study to include the faculties of theology, canon and civil law, arts, medicine and other lawful faculties. According to the 1969 book *St Andrews, Town and Gown, Royal and Ancient* by Douglas Young, the Pope states in his bull,

> considering also the peace and quietness, which flourish in the said city of St Andrews and its neighbourhood, its abundant supply of victuals, the number of its hospices and other conveniences for students, which it is known to possess, we are led to hope that this city, which the divine bounty has enriched with so many gifts, may become the fountain of science, and may produce many men distinguished for knowledge and virtue.

This is either a sign of the false picture created in the application for the bull, or the Pope's misconceptions about the reality of St Andrews at the time, yet is a fitting description of the university, city and surrounding area today.

DID YOU KNOW?

St Andrews nearly lost its university just thirteen years after it was founded. James I of Scotland felt that Perth was better suited to provide the facilities and in 1426 addressed a petition to Pope Martin V to have the university moved. Only after he narrowly failed did he issue charters for the concessions and confirmation of the privileges of the university, and set about improving the existing facilities.

A total of six bulls were issued by Pope Benedict, and a young priest of the diocese of St Andrews named Henry Ogilvy was sent to Peñiscola in Spain to collect the bulls. When he returned to St Andrews on 13 February 1414, he was met by the great bells of the cathedral ringing to honour his arrival. The following day, they were presented to the bishop in an elaborate ceremony at the cathedral, attended by approximately 400 clerics, after which the locals participated in lighting bonfires in the streets and wine was said to have 'flowed like water'. It is fair to say that the formal establishment of St Andrews University was a joyful occasion for all!

The King James library.

Bishop Wardlaw was appointed as chancellor to the university, and the first rector, or master, was Laurence of Lindores. Born during the 1370s, and having studied at the University of Paris from 1393, Laurence of Lindores also held another position, that of the Inquisitor of Heretical Pravity, a heinous role that saw him responsible for rooting out heresy in the country. The sufferings of those accused of heresy will be discussed in more detail in a later chapter, however, it should be mentioned that Laurence of Lindores is widely credited (to his shame) of lighting the first martyr fire in Scotland.

The earliest university building was St John's College, which stood on South Street on an area of land gifted to the university by Robert of Montrose. Unfortunately, no records remain of that college and what remained of the building was incorporated into the King James Library building, construction of which was started in the seventeenth century.

The next school of learning to be established was the College of the Holy Saviour, now known as St Salvator's, which was founded on 27 August 1450 by Bishop James Kennedy. This residential college was founded for students of theology and arts and provided training for priests as well as a college church for daily worshipping. Those attending were expected to follow very strict instructions regarding their character and duties, with the following statute being contained in the charter of foundation:

We ordain farther that all the members of the said college live decently, as becomes ecclesiastics; that they not be common night walkers or robbers or guilty of other notorious crimes; and if any one of them is so, (which God forbid) let him be corrected by his superior; and if he proves incorrigible, let him be deprived by the same superior, and another substituted in his place.

With the 'corrections' that were administered including public floggings, most students abided by this statute.

The most dominating feature of the college was the entrance tower, which stands at around 38 metres tall; when originally constructed, it did not have the spire and so was shorter. Passing through the archway in the tower, you enter a large quadrangle surrounded by grand buildings.

In 1512, St Leonard's College was founded by the Archbishop of St Andrews, Alexander Stewart, and prior John Hepburn in the hospital of the St Leonard's building, close to the cathedral. The hospital had originally been constructed to accommodate pilgrims visiting the shrine of St Andrew, but rather bizarrely, on 20 August 1512, the archbishop and prior acknowledged that the power of the relics to perform miracles had been in decline and, as a result, the number of pilgrims was reducing. With fewer pilgrims, there was no need for the hospital, and so the building was chosen to create the new college. By then, the early rumblings of the Reformation had started in Scotland, which was most likely why there had been a drop in pilgrims, and the ripple effect was being felt in the hierarchy in St Andrews. While papal bulls were obtained for the foundation of the colleges of St John's and St Salvator's, none were applied for the foundation of St Leonard's College. In 1544, Cardinal David Beaton deemed himself to have enough apostolic power to ratify the charters of the college.

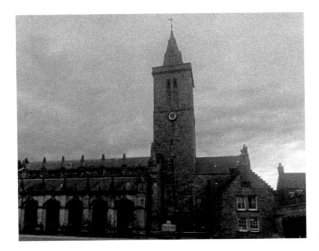

St Salvator's Clock Tower.

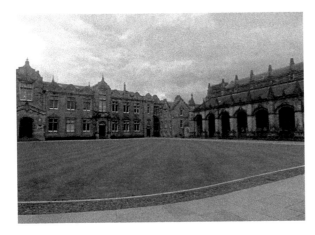

St Salvator's quadrangle.

The final college to be created prior to the Reformation was the New College of the Assumption of the Blessed Virgin Mary, more commonly known as St Mary's College. This college was founded in 1538 by Archbishop James Beaton, with the aim to preserve the teachings of the Roman Catholic Church under a papal bull from Pope Paul III. When Cardinal David Beaton succeeded his uncle, he continued to develop and improve the college until his assassination in 1546, after which the college was passed to the control of Archbishop John Hamilton, who further remodelled it. A hawthorn tree grows in the gardens, which is believed to have been planted by Mary, Queen of Scots.

The country was in the grips of the Reformation. The Scottish Parliament of 1560 adopted the Protestant faith and an Act of Parliament followed in 1561 which ended the Pope's authority in Scotland, breaking all connections between the university and the church. Ten years later, in 1571, John Hamilton was hanged by the common executioner in Stirling for a crime committed by his nephew, having never taken up residency in St Andrews.

The university possesses three medieval ceremonial maces, something that is believed to be unique among universities. The first was made on behalf of the Faculty of Arts in

St Mary's College.

Mary, Queen of Scots' hawthorn tree.

1416, for the sum of £5, to represent their authority. It was made in Paris, but added to in St Andrews, and comprises of a silver rod approximately 130 centimetres long. Each side of its hexagonal head depicts a saint and an angel holding a shield. Each shield carried a different coat of arms representing important people in the establishment of the university, those being the King of Scots, the Duke of Albany, the Earl of Mar, the Earl of Douglas, Bishop Wardlaw and Pope Benedict XIII (later replaced with the arms of Archbishop Spottiswoode). The mace was first used in 1418 when, at a grand council in Perth, the university renounced obedience to Pope Benedict XIII and acknowledged Martin V as the rightful pope.

The second mace was made for St Salvator's College on the instructions of Bishop Kennedy in 1461. Again, this was made in Paris by the goldsmith Johne Maiel and is gilded in silver. The hexagonal head is extremely grand and complex, depicting a shrine that contains a large figure of St Salvator on a globe. Three angels surround the central figure and below the angels are three doorways containing a chained man and shields

DID YOU KNOW?

In 1460, Bishop Kennedy added a bell measuring approximately 80 centimetres in diameter and 56 centimetres high in the belfry of the tower of St Salvator's, which he named Katharina. The bell was recast in 1609 and again in 1686, by which time the bell was known as Katharine. It is very likely that this was the inspiration for the tale of the niece of Bishop Kennedy, Kate, who won the hearts and affection of the students and is celebrated in the annual Kate Kennedy Parade.

representing St Andrews, Bishop Kennedy and St Salvator's College. The chained men are considered to represent disorder and chaos, possibly a reflection of the country at the time. The mace head also bears the figures of a king, a bishop, a merchant, preachers and six lions, with another four lions on the rod.

The third mace, considered to date to around the mid- to late fifteenth century, is a copy of that made for the Faculty of Arts, although it is of poorer quality. This mace was most likely made in Scotland, making it potentially the rarest, despite the quality. The maces are still used up to twice a year for graduations.

Perhaps the most visually symbolic item for students at the university is the iconic red gown worn by undergraduates, mainly now for special events only. Although early records show students at the university had a dress code of cloaks with hoods, the scarlet gown appears to have been introduced by James VI in the first half of the seventeenth

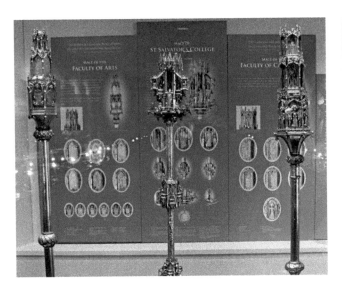
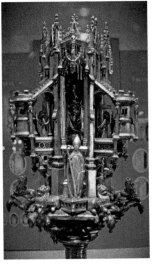

Above left: The three maces.

Above right: St Salvator's Mace.

century, although the earliest records state the colour dates back to 1677. The position the gown is worn indicates the students' position in their studies. First years are required to wear the gown properly, with both shoulders covered, whereas in second year the gown is worn in a shrugged position, lower on the back, but with shoulders still covered. Third-year students are allowed to shrug the gown lower, exposing one shoulder, the left shoulder for students of art, and the right shoulder for students of science. In their fourth year, the students wear the gown completely off their shoulders and down around their elbows, seen as them 'shrugging off' their university life.

One of the most accomplished tutors of the university was an astronomer and scientist named James Gregory. Born in November 1638 in the parish of Drumoak, just outside Aberdeen, Gregory studied theology at St Andrews University before going on to work in London and Italy. As a gifted mathematician, some of his theories led to the start of a rivalry with Sir Isaac Newton when his work was published, and it transpired Newton had been working on the same principle. There was no indication of bitterness between the two men; Gregory is said to have respected the work of Newton, yet it did lead to some reviewers questioning whether one had copied the other's work.

In 1668, Gregory returned to St Andrews to take up the role of the Chair of Mathematics, a position created by Charles II. He set up his laboratory in the upper floor of the library building on South Street, where he continued his research. It was here that again his work would clash with that of Newton's when he created what is now known as the Gregorian telescope, a design for a reflecting telescope. This pre-dated Sir Isaac Newton's Newtonian telescope, which is widely considered to be the first reflecting telescope, by five years. Gregory used his telescope for astronomy, and from his research and observations, he set out a meridian line across the floor of his laboratory, which pre-dated the Greenwich meridian line by 200 years. This important record was largely forgotten until 2014, when a brass line was laid into the pavement outside his former laboratory, continuing his meridian line, and a plaque acknowledging his work was laid – this attracted extensive media coverage and St Andrews was named 'the place where time began'.

The Gregory Meridian Line.

The plaque acknowledging Gregory's achievements.

DID YOU KNOW?

As well as being the first university in Scotland, the University of St Andrews lays claim to a number of other firsts. The first student to graduate in Scotland was William Yhalulok (or Zalulok) who graduated with a Bachelor of Arts from St Andrews University in 1413. In 1892, the university became among the first to allow women to matriculate. The university has the lowest dropout rate in Scotland and is home to one of the largest and most important collections of historic photographs and over 1 million books.

4. The Origins of Golf

Scotland, and more specifically St Andrews, is generally considered to be where golf originated. Although some will tell you that the word 'golf' is an acronym for 'gentlemen only, ladies forbidden', which is certainly true for the past centuries and, for some clubs, still pertinent today, the actual origin lies before the game was created. There are a number of theories as to where the word golf, or *goff* as it was commonly spelt centuries ago, was derived. Some state it is a variation on the Dutch word *kolf*, which is a type of club, while others speculate that it comes from the old Scots word *golfand*, meaning 'to strike'. The game itself is considered to be based on a Roman pastime, which was played with a leather ball stuffed with feathers, much the same as some of the early golf balls, or a game played by the early Gaels known as iomain, which involved driving a leather ball stuffed with wool into a small, low goal using a curved stick.

How and why people started playing golf in St Andrews is something that is unclear. The Links land was gifted to the people of St Andrews by King David in 1123, but golf was not believed to have been played there until the early 1400s. The earliest official document relating to the game is in fact one that banned it. By 1457, James II of Scotland was having issues with his archers, who did not match the skill and accuracy of the opposing armies. It became evident to him that young men in many locations were turning their backs on the traditional pastime of archery, which naturally nurtured archers for future armies, and were instead opting to play golf. On 6 March 1458, an Act of Parliament was issued

Bow Butts, where archery was practised.

DID YOU KNOW?

One of the most iconic images of the Old Course is the Swilcan Bridge, a small stone arch providing a crossing over the Swilcan Burn, which flows across the course to the sea. The bridge itself is estimated to be around 700 years old and was originally constructed to aid shepherds and farmers in moving their livestock across the river.

by King James, making the playing of golf an offence against the state. Instead, every Sunday targets were set up close to the parish church, and every man was required to fire at least six arrows. Anyone failing in this duty faced a fine of two pennies, with all of the fines accumulated and split between those who had fired the required number of shots, to allow them to buy drinks.

Although it is likely that most complied with the stipulation to fire the arrows, it is fair to assume most would prefer to be receiving the drinks rather than paying for them. The ban on golf was not so strictly adhered to, prompting the parliament of James III to issue a further order on 6 May 1471, which again required all men to take part in military exercises (most likely archery) and that other exercises such as golf (and football) were to be abandoned. It seems that the draw of a game of golf was so strong that many still ignored the commands of their king, prompting James IV to again issue a ban on the game twenty years later. He went further, stating that sports such as golf were unprofitable, and instead men were to take part in sports for the common good and defence of the realm, such as archery. For every breach of this act, a fine of forty shillings would be imposed on the parish as a whole. Even this was not enough to put people off, and in 1502, rather than face the embarrassment of being ignored further, James lifted the ban and bought himself a set of golf clubs from, rather curiously, the bow maker in Perth, again a sign of the ties between archery and golf.

On 25 January 1552, Archbishop John Hamilton of St Andrews granted permission for the Links to be used for the purpose of playing golf, while reserving the rights for the community to pasture their animals and dig turf for burning in fires or covering roofs (perhaps this was the origin of the bunkers). The same document also protects the archbishop's rabbits that roamed the area and the townsfolk were banned from poaching them. The rabbit burrows were to be confined to the north part of the Links. It is quite imaginable that a game of golf in these days would be both difficult and interesting at the same time. This, however, legitimised the game and was the start of the creation of the course known as the Old Course, probably the most famous course in the world.

The original course would have consisted of natural obstructions created by the sand dunes and a heather-covered fairway, which probably made it difficult to differentiate between the fairway and the rough. The game was played with short stick dubs and, originally, wooden balls, which were prone to split, before the introduction of the feather-filled balls. The same holes were used for both outward and inward play.

The Old Course.

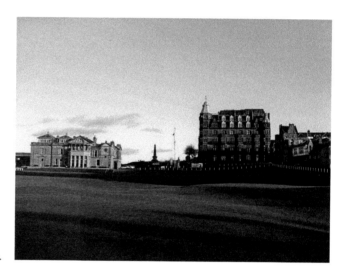

The Old Course.

In St Andrews, the town's archery field was at Bow Butts, the large grassed area opposite the Old Course, and so it is possible to see how the two sports competed for attention in the early days. Around 1618, possibly in an attempt to retain the traditions of archery among the students, an annual competition was established between the colleges of St Salvator and St Leonard to determine the top archer at the university. Known as the Silver Arrow competition, the winner was allowed to provide a medal that would be hung on a ceremonial silver arrow, which was carried at the head of the procession marking the start of the competition.

Golf still flourished in the town, although still with some restrictions. In March 1598, David Gray and Thomas Saith were accused of playing golf on a Sunday, and after begging for the forgiveness of the Church, they were told if they were caught again they would be fined forty shillings each. In December 1599, no doubt realising this could be lucrative

for the Church, fines were formalised for anyone playing golf at 'times fixed for divine services' at ten shillings for the first offence and twenty shillings for the second offence. If a third offence was committed, the guilty parties were required to perform a public repentance and a fourth offence would result in them being deprived of any privileges they may be entitled to. The fact the penalties went up to a fourth offence is a pretty clear indication that, again, the expectation was for the ruling to be ignored. In 1618 James VI, having received many complaints from the ordinary people of Scotland, ruled that it was permissible to participate in lawful recreation, including golf, after the church service had ended, but also ruled that anyone who had not attended church would not be allowed to go on to engage in any pastimes.

The Swilcan Bridge.

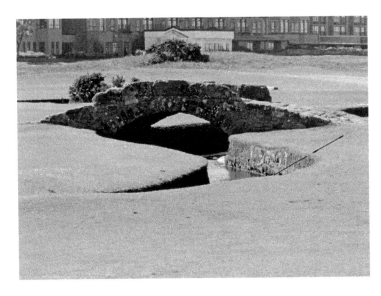

The Swilcan Bridge and Burn.

DID YOU KNOW?

James Graham, 5th Earl and 1st Marquess of Montrose (1612–50), was a student at St Salvator's College in St Andrews. He won the Silver Arrow archery competition and went on to lead the Royalist forces in the Scottish Civil Wars with several significant victories, leading him to be known as 'The Great Montrose'. The records also show that between 1628 and 1629, he paid £11 8s for six new clubs, dressing old clubs and golf balls, clearly showing that in St Andrews it was possible to play golf, practise archery and have an accomplished military career.

DID YOU KNOW?

The Swilcan Burn is the only watercourse on a golf course that is protected by an Act of Parliament. Under the threat of imprisonment or a fine, no one is permitted to wade in the Swilcan Burn, because of the distance it flows across the Old Course. No one other than players or caddies are permitted to recover golf balls from the burn, or do anything that would discolour the water.

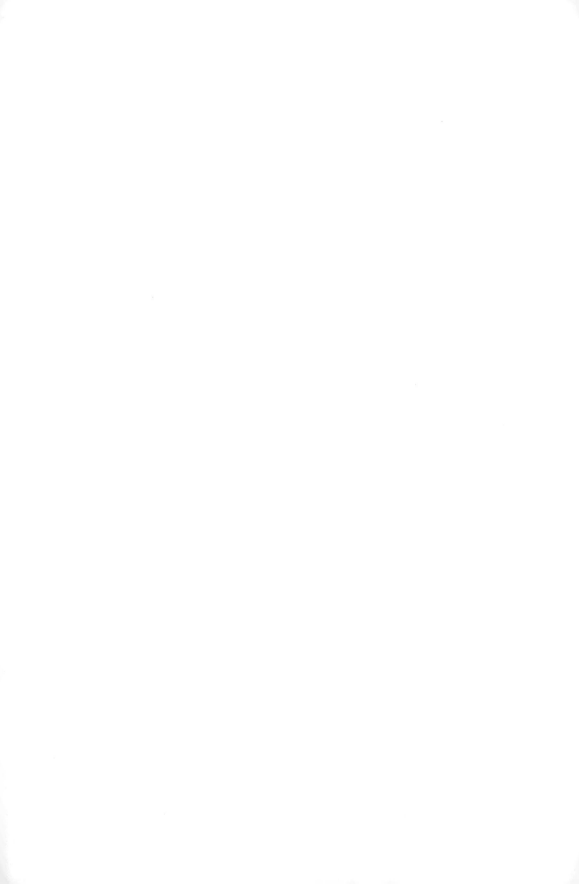

5. The Fall of the City

Although it was religion that first brought prominence to St Andrews, it was religion that led to the decline of the town, with events that happened in St Andrews leading to change throughout the country. In the sixteenth century, there was religious unrest, with an uprising of Protestant reformers. In St Andrews, a young man named Patrick Hamilton arrived, who had travelled through parts of Europe and met with the Fathers of the European Reformation, such as Martin Luther – he was keen to pass on his new knowledge.

Hamilton took a place at St Leonard's College in St Andrews and soon began preaching the new ways of religion that he had learned in Europe. With Scotland still following the Catholic faith, and St Andrews being the headquarters of the Scottish Church, Hamilton's actions did not go unnoticed and, as he began to find a following among his fellow students, action was taken to stop any momentum and crush any uprising. Dr James Beaton, the Archbishop of St Andrews, ordered Hamilton's arrest on the charge of heresy. Word reached him before the guards could carry out their orders, and Hamilton fled to Germany, where he stayed for several months, before returning to Scotland. He knew his life was in danger, yet such was the strength of his faith he was willing to face whatever fate awaited him rather than live in hiding.

Beaton formulated a plan to trick Hamilton into a false sense of security and allowed him to start to preach again, before inviting him to St Andrews Castle, where he said

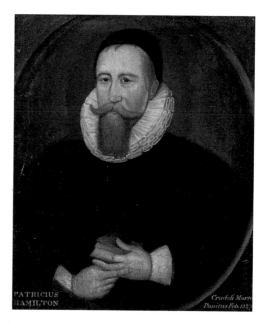

Patrick Hamilton.

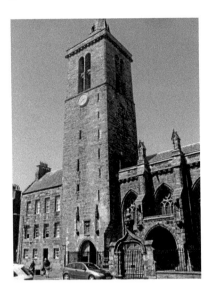

St Salvator's College.

he wanted to discuss the new ways of religion with him. Although he had doubt and suspected it might be a trap, it seemed Hamilton was willing to take that chance for the opportunity to try to convert the archbishop. Instead, he was seized on the charges of heresy and, having been convicted, was sentenced to death. On 29 February 1528 he was bound to a stake with iron chains outside the chapel of St Salvator.

Although it was common for the accused to be choked to death before the fire was lit, due to his refusal to deny his Protestant beliefs, Patrick Hamilton was to be burned alive.

Due to the speed of the arrest, conviction and execution, only a small pile of wood and coal had been gathered and stacked below him. A mix of kindling and gunpowder was also placed in the centre to light the fire and encourage it to burn quickly before a trail of gunpowder was laid to a safe distance where, on the command, a flaming torch was placed to the powder and it ignited. It is difficult to imagine the thoughts going through Patrick Hamilton's mind as he watched the sparkling flame follow the gunpowder trail, getting ever closer to him. Whatever he imagined, the horror he truly faced was far worse. There had been too much gunpowder and not enough kindling used, and rather than light the fire, the explosion simply blasted the kindling out from the timbers. Patrick Hamilton suffered severe burns to his hands and face; yet, he was left there while another mix of gunpowder and kindling was prepared. The process was repeated, but again was only successful in causing more burns to Hamilton's body. By this time, all of the gunpowder that had been brought had been used, so Hamilton was left in agony while fresh supplies were brought from the castle. While they waited, Friar Alexander Campbell of the Blackfriars first urged Hamilton to repent, before verbally abusing him and condemning him to face the judgement of Christ when he refused.

On the third attempt, the fire was eventually lit, but it burned very slowly. No doubt sensing that the crowd of townsfolk who had gathered to watch a spectacle were unhappy with the poor performance, the fire was checked and the wood found to be damp. Knowing that the crowd could turn at any moment and may even try to free Hamilton,

The remains of Blackfriars Chapel.

guards were quickly sent to gather more wood from the castle. As soon as this was thrown into the flames, the fire quickly gathered pace and Hamilton's ordeal was over. Just before he died, he gathered the strength to shout 'How long, O Lord, shall darkness overwhelm this realm? How long wilt thou suffer this tyranny of men? Lord Jesus, receive my spirit.'

It had taken six hours for Patrick Hamilton, who was just twenty-four years old, to die. Today, the letters 'PH' mark the area where he perished and, more curiously, if you look up towards the spire of St Salvator's clock tower, on the fifth row of stones above the coat of arms, a face is visible in the stonework. Legend states that this is the face of Hamilton, forever burned into the stones of the tower by the energy created from his prolonged, agonising death.

Patrick Hamilton was the first Protestant martyr to be executed in Scotland; yet the brutality of his death did not quell the Protestant movement. If anything, it promoted

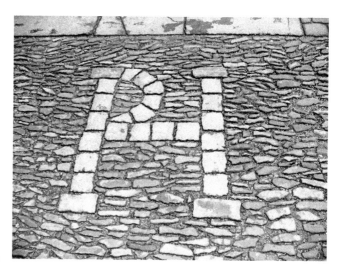

The spot where Patrick Hamilton was burned to death.

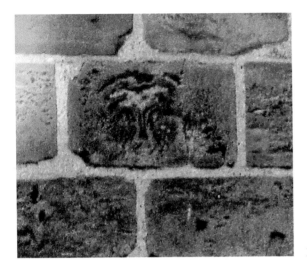

Patrick Hamilton's face.

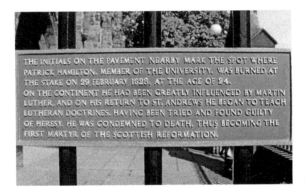

Patrick Hamilton's memorial plaque.

it to grow, creating an ever-greater threat against the Catholic religion in Scotland, and in particular, St Andrews. There was some unease at the suffering Hamilton had endured and, to add to the concern, Friar Alexander Campbell began to suffer from an unexplained illness soon after the killing of Patrick Hamilton, and he died within a year. In such superstitious times, many believed that this was a clear sign that it was Campbell who had faced the judgement of Christ, rather than Hamilton.

The second reformer to be executed in St Andrews was Henry Forrest, described in the 1830 book *Martyrs, or a History of Persecution* by Martin Ruter, as being a 'young, inoffensive Benedictine'. His crime was being caught in the possession of a copy of the New Testament, written in English. For this, he was arrested and held in the sea tower of St Andrews Castle while the evidence was considered. Concerned that possession of the New Testament alone may not be enough to secure his execution, a friar named William Laing stated that Forrest had called upon him to hear his confession and, in secret, he had revealed that he thought Patrick Hamilton was a good man and that his execution had been wrong. On the strength of these sympathies towards Hamilton, along with the possession of the New Testament, Henry Forrest was sentenced to death in 1533. The

location of his execution varies between historical records. In the 1844 book *The Acts and Monuments of the Church* by John Fox, it states that he was burned at the stake close to the north stile of the Abbey Church of St Andrews, a location specifically chosen so the fire could be seen from the opposite side of the Tay Estuary, to serve as a warning to others against following the new ways. In Martin Ruter's book, mentioned earlier, a different version is given, where it is stated that John Lindsay, one of the archbishop's gentlemen, warned that Forrest should be burned in a cellar, as the smoke of Patrick Hamilton had infected all of those on whom it blew. He advised that this concern was acted on, however, he wished that should be Forrest was suffocated to death in a cellar, rather than be burned.

In 1539, James Beaton was succeeded by his nephew, Cardinal David Beaton. Anyone looking at David Beaton's past would see he was an accomplished man. Having been educated in St Andrews, he had travelled to Paris when he was just sixteen years old to continue his studies, and in 1519, at the age of twenty-five years, James V of Scotland appointed him as his ambassador in France. Six years later, he returned to Scotland to take the position of Abbot of Arbroath, along with a seat in the Scottish Parliament, and in 1532, he was named the Lord Privy Seal, one of the senior positions in Parliament, by the king. The reality was however that he would become a prolific persecutor of the Protestant reformers with levels of brutality that made some believe he was in league with the Devil.

From early on, and before he took the role of Archbishop of St Andrews, Cardinal Beaton had been a trusted counsellor to the king and had used his links with France to play a significant part in arranging the king's marriage to Madeleine of Valois, the daughter of king Francois I of France, in 1537. Madeleine suffered from poor health and, because of concerns raised by the doctors who attended to her about the Scottish climate and pollution in Edinburgh, a residence was constructed for her in St Andrews, named the Novum Hospitium, or the New Inns, at the bottom of the Pends. Sadly, St Andrews was not to be the home for the new queen as, less than two months after she arrived

Gateway to the New Inns.

in Scotland and a month before her seventeenth birthday, she died from suspected tuberculosis having never made it out of Edinburgh. All that remains of the New Inns today is the gateway.

Perhaps as a sign of the times, work quickly started to find another bride for the king. Again, Cardinal Beaton was instrumental in the negotiations, and less than a year after the death of Madeleine, the marriage of James to Mary de Guise, a member of a prominent French noble family, was agreed. Mary sailed from France to just outside Crail in Fife, around 10 miles from St Andrews, where she was escorted to the New Inns and stayed for two days before her marriage to James in St Andrews. They would go on to have two sons, the eldest of whom was born in St Andrews, christened in St Andrews and lived in the town throughout his short life as, in April 1541, tragedy was to strike when both sons died in their infancy. On 8 December 1542, they went on to have a daughter, but James, who had been suffering from an unknown illness for some time, died on the 15 December, leaving his eight-day-old daughter as the direct heir to the throne. Cardinal Beaton again stepped forward and sought to gain the role of regent to the infant queen, which would not only give him control of religion but also of the Crown. He produced a will, signed by James V, which appointed him as co-regent for the queen; this was later revealed as a forgery, most likely created by Beaton himself, and he was imprisoned. On his release he

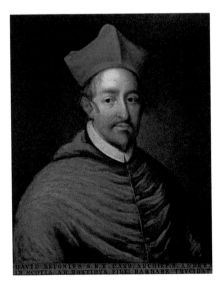

Cardinal David Beaton.

was sent back to his castle in St Andrews. The young queen would go on to be known as Mary, Queen of Scots, one of the most pivotal characters in Scottish history.

Having failed in his attempts to gain greater power, Cardinal Beaton's attention returned to the reformers, who still presented a threat to the authority he still held. Meanwhile, a battle had been initiated between Henry VIII of England and Henri II of France to win agreement for the marriage of young Mary to their sons. Henry hoped to not only bring together the English and Scottish crowns but, as England was already moving towards Protestantism, he hoped to encourage the Reformation in Scotland and bring the Church of Scotland in line with the Church of England. Catholic France meanwhile sought to keep Scotland as a Catholic country to ensure the continuance of the 'Auld Alliance' between Scotland and France, which was a formidable threat against England, both in religious and military terms. Henry opted to use force to try to secure victory, and sent raiding parties into Scotland, a period known in history as the 'rough wooing'. Many ordinary Scots saw this tactic as being in direct retaliation to Cardinal Beaton's actions against the reformers, leading him to become deeply unpopular.

The cardinal was to seal his own fate in 1546. His attention had been drawn to a Protestant reformer named George Wishart some time before when Wishart, who had spent time in England when the Reformation was well underway, returned to Scotland.

His return was met with much anticipation and he quickly gained a following. Beaton used his influence to force him out of several towns to stop him from preaching, but Wishart would not be halted. Word reached him that the plague had struck the city of Dundee, around 10 miles north of St Andrews, four days after Wishart had left. Rather than being thankful that he had avoided the disease, Wishart returned to the city to offer prayers for the dying. Cardinal Beaton reached out to a young priest in Dundee, over whom he had some influence, and persuaded him to assassinate Wishart, but Wishart spotted the dagger under the priest's cloak and challenged him, after which he fell to his knees

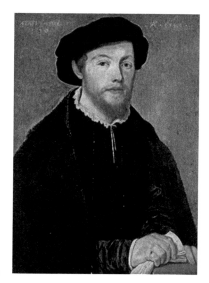

George Wishart.

and confessed all. The people of Dundee were keen to seek vengeance on the priest, yet Wishart again showed compassion and dissuaded them from doing so. In December 1545, he travelled to Leith, where he met with friends, and they were surrounded by the men of the Earl of Bothwell. Wishart offered to surrender himself to the earl, having received an assurance that the others in his party would be allowed to go free and the earl stated that Cardinal Beaton would not have any say in what happened to him. Unfortunately, this was not the case, and soon after being imprisoned in Edinburgh, George Wishart was sent to Cardinal Beaton's castle.

Beaton, aided by the Bishop of Glasgow, gathered a group of like-minded church officials to judge Wishart. On 28 February 1546, he formed a court of his clergy and George Wishart was taken from the castle to the cathedral, escorted by as many as 100 armed guards, which must have created quite a scene in the town. The charges against him were read out, but he was not to be allowed to respond due to the judges calling out and laughing at him. The trial descended into a mockery of the justice system, and Wishart was ultimately found guilty of heresy and condemned to be burned at the stake. The preparation for the execution was made immediately and the following day Wishart was escorted to a gruesome sight. A scaffold had been erected in front of the castle, with a stake in front. A rope was placed around his neck, chains around his middle securing him to the stake, and his hands were tied behind his back. According to a short, undated pamphlet entitled 'The Life of George Wishart; The Scottish Reformer', all of the castles artillery was pointed towards the scaffold out of fear of rescue attempts. The same document states that the executioner asked Wishart for forgiveness, which he was granted, before the fire was lit. Despite small bags of gunpowder being hung from the chains, his death was not quick and he survived the explosions. As he suffered the pain of being burned alive, the captain of the castle, who had been moved by Wishart's strong willpower and endurance, spoke to him

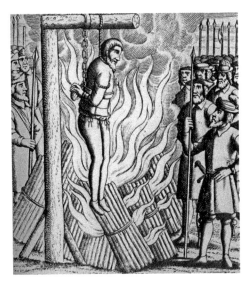

The Martyrdom of George Wishart: Artist unknown.

Initials G. W. to mark where
George Wishart was martyred.

before indicating to the executioner to tighten the rope around his neck. His ordeal
was ended and his fortitude preserved.

Cardinal Beaton had watched the whole occasion from the luxury of his castle with some
satisfaction. The biggest threat against his church had been removed. Or so he thought. He
had failed to take into account the following George Wishart had established, along with
his own unpopularity. It had not gone unnoticed by the crowd that the cardinal had been
seated at the window, which had been specially prepared for comfort. His apparent delight
at the death of Wishart only succeeded in growing hostility against him. It appeared that
Wishart himself foresaw what was to happen next, with his last words to the captain of the
castle reported to be 'This flame has scorched my body, yet it has not daunted my spirit; yet
he who from yonder place beholdeth it with such pride, shall within a few days lie in the
same, as ignominiously as he is now seen proudly to rest himself'.

On 29 May 1546, a group of ten men, all supporters of George Wishart, silently joined a
group of workmen as they made their way to the castle. To avoid the risk of detection, they
had split into two groups, and while the first group successfully made it into the castle,
the second group were challenged by the gate porter. Before he could raise the alarm, they
grabbed him, took his keys and threw him into the moat. The workmen who witnessed
this feared for their own lives and fled the castle. The mass of bodies passing through the
narrow access stopped any guards on the outside from coming in. The ten plotters found
themselves in an undefended castle, alone, with the exception of Cardinal Beaton. As
they approached his quarters, the cardinal locked himself inside his chamber and refused
demands to open the door. When his assailants threatened to burn the door down, he
opened it and made a last ditched effort at pleading for mercy. He was shown as much
sympathy as he had shown George Wishart. The men burst into the room and stabbed
him repeatedly, mutilating his body. In a final show, they secured a rope to one arm and
one leg and hung his body from a window, so his limbs formed the cross of St Andrew. The
window from which he was hung was the same one from which he had sat and watched
Wishart's execution. A new frontage was later added, but a window remains in the area.

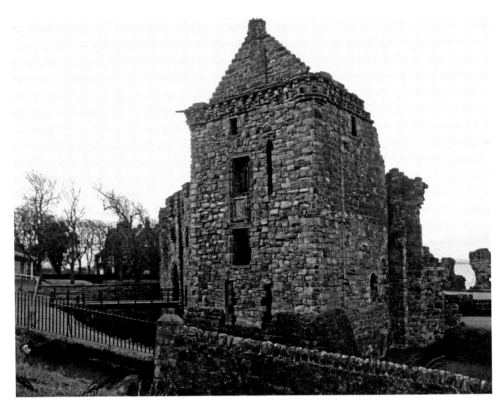

The proximity of the window where Beaton sat.

The assassins found themselves in a predicament. They had secured the castle, yet the cardinal's guards and the might of the Church awaited outside for them. With the period of rough wooing still on-going, they decided to try to hold the castle until the English army reached St Andrews, knowing that Henry VIII was likely to grant them leniency for removing the Catholic archbishop. Surprisingly, they were successful in holding the castle for about a year, most likely due to the attempts to retake it being minimal. During this time, they had been joined by other supporters, including a preacher named John Knox, a former pupil of Wishart. Their luck was to run out in June 1547, when the French navy arrived in St Andrews Bay instead of the English land force they hoped for. With France still holding on to the Auld Alliance and wanting Scotland to remain Catholic, their assistance had been requested by the Scottish Church and the ships sent to remove the threat. With an engineer leading the French fleet, the men within the castle could only watch as pulley systems were constructed and cannon hoisted to high vantage points all around. Reports state that one of the places chosen was on top of the square tower, which many perceive to mean St Rule's Tower (which is now commonly known as the square tower). It was, however, St Salvator's Tower on which the cannon was mounted, and considerable damage was caused to the tower as a result. The bombardment that followed soon demolished most of the castle and it soon became clear that surrender was the only option. The ringleaders surrendered to the French general,

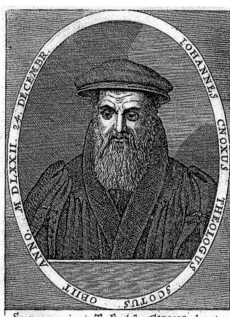

*Scotorum primum Te Ecclesia CNOXE, docentem
Audijt. auspicijs esteq reducta tuis .*

a a 4

John Knox.

who offered them better terms than the Earl of Arran. They were taken to France, from where they would be taken to any country they wished, other than Scotland. However, the terms of this agreement were not adhered to, and while some of the men found themselves spending time in French prisons, others, including John Knox, were put to work in the galleys of the French ships.

In St Andrews, the church continued to try to cling on to power, but it was too late. There was an air of change as the people across the land started to turn towards the new form of Christianity. John Knox, having survived his time in the French gallies, returned to Scotland and St Andrews where, in June 1559, he delivered a strong and fierce sermon in the town's parish church. Such was the power of his words, the townsfolk left the church and set about attacking the religious establishments of old, driving the clergyman away and demolishing their structures. The time of St Andrews being a religious powerhouse was over.

DID YOU KNOW?

Cardinal Beaton's body was kept in the bottle dungeon for the year that the castle was held by his assailants. It was preserved in salt, and it is believed to have been later buried at Blackfriars Chapel.

6. The Killing Years

The Reformation sent shockwaves throughout Scotland, but they were felt the hardest in St Andrews. The town had been built on religion, and the university had been formed on the basis of that religion. The bakers, brewers, butchers, tailors, fishermen and virtually every other business or trade that operated in the town relied on these two great establishments to survive. The bishops and clergymen had been driven from their churches and chapels, and their once-grand buildings, including the cathedral, were in ruins. The rebuilt castle survived for a short while but, having been abandoned, it was destined to fall into a state of disrepair. As the old saying goes 'things have to get worse before they get better', and this was certainly true in the case of St Andrews.

The university buildings survived due to the actions of Principal Douglas who, along with many others involved with the university for the previous decade, opted to embrace the Protestant Reformation, after which St Mary's College was re-established as the Faculty for Christian Studies. That is not to say none of the university buildings were damaged. St Salvator's Chapel was once richly decorated with statues of the saints and other biblical figures in the niches that surrounded the exterior, all of which were smashed by the reformers.

The largest impact on the university was economic. With the authority of the pope being no longer recognised, the papal bulls were irrelevant. The privileges that were

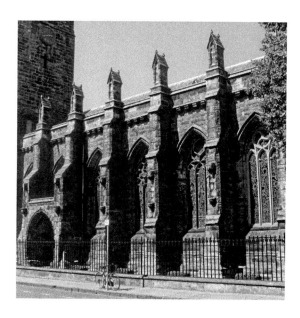

The empty niches at St Salvator's Chapel.

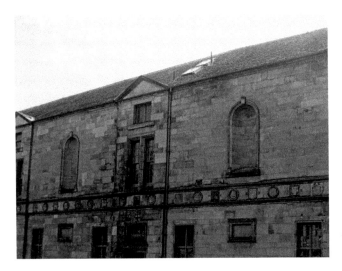

The empty niches at Parliament Hall.

granted to those involved in the university were removed and, as most of the funding had previously been received via the church, this income was now seized by the Crown.

Mary, Queen of Scots had returned to Scotland from France in 1561. On the recommendations of her advisors, she acknowledged the reformed Presbyterian Church and granted it some rights, although she did not give it a full authority. Despite several run-ins with John Knox, who had become the leader of the Reformed Church, the Catholic queen and the new church tolerated each other. While many had hoped that the new church would offer new opportunities, especially towards women who gained educational rights, sadly that was not the case. The killings in the name of religion did not end, and in 1563 the Witchcraft Act was introduced, which was intended to discourage women from taking up their new rights and remain within the restraints of the queen's religion, while also stamping out any remnants of the old pagan religions.

To be accused as a witch was a horrific prospect. The penalty was death, and with the act ruling that anyone assisting a witch would face the same penalty, if you were accused, you could not rely on receiving support, even from your friends and family. This was sufficient to ensure that the majority of the population were well behaved as, even a statement from a disgruntled neighbour, was enough to be charged. It was an easy, and legal, way to get rid of anyone you did not like or who did not fit in. Equally, the act made it punishable by death to seek the assistance of a witch, discouraging people from seeking the help of traditional healers, many of whom followed Pagan traditions.

The place of execution for witches in St Andrews was the hill overlooking the Bow Butts, the town archery field. The area is still known as Witch Hill, with the sea pool below the cliffs being known as Witch Lake.

Despite the name, there are no records of witches being 'swum' in the lake, that is the tradition of binding the left thumb to the right ankle, and the right thumb to the left ankle, before throwing them in the water. As water was deemed to be pure, if the accused drowned, this was a sign that the water accepted them and so they were innocent (but dead). If they survived, it was considered the water was rejecting them, a sign they

Witch Hill.

Witch Lake, now site of the Sealife Centre.

were guilty, and they were executed. It is likely that the name for the lake came from its location to Witch Hill during the Cromwell years.

It is widely believed that the first witch to be burned at the stake in the town was named Nic Neville in 1569. Very little more is documented about the accused or the trial; it is not even clear whether they were male or female. Later in the same year, William Stewart was tried for treason by Sir Patrick Learmouth. The records do indicate this was, in fact, Sir William Stewart of Lutherie, the Lyon King of Arms (a crown minister position) and that he was hanged rather than burned. Exactly what act he was accused of that would result in him falling into the category of witchcraft list is not stated. Several other accused witches are named as residing in St Andrews, including Marjorie Smyth in 1576, who fled with her husband before the trial, and Bessy Robertson in 1581, who surprisingly got off with a warning; however, a trial in 1588 concerning a young woman named Alison Pearson is particularly notable.

Alison lived in Boarhills, a small village just a few miles from St Andrews, and is noted as being a particularly skilled herbal healer. She learned her art in a small den, which still contains relics of past religions.

A druid's sacrificial pool near where Alison learned to heal.

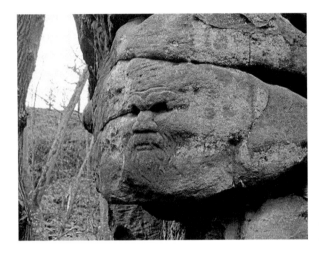

A Green Man carving near where Alison learned to heal.

She attracted the attention of Patrick Adamson, the Archbishop of St Andrews for the reformed Catholic Church. Adamson had been suffering from a number of illnesses that no doctor could treat. He called on Alison, who agreed to consult with him, in 1583. She treated him at a house in South Street, probably one of the properties owned by the Knights of St John, after which Adamson went on to make a full recovery, something seen as quite miraculous given that the doctors could not cure him. Word soon got out that it had been Alison Pearson that had restored his health, something that his Protestant opponents jumped on. He had consulted with a witch. Adamson retreated to the castle, where he managed to hold out, and Alison fled. As she was never convicted of being a witch, Adamson could not be tried with consulting with a witch. He had survived that battle. Five years later, Alison was captured by the authorities and brought back to St Andrews to stand trial. Archbishop Adamson, by this time, was fighting accusations of heresy made against him, the same charge that he would face for consulting with a witch, and so his opponents did not pursue a case against him again. Adamson was

excommunicated from the church, whereas poor Alison Pearson, having confessed, no doubt under torture, to have been taught the art of healing by the fairy queen (fairies in these days were deemed nasty creatures, too bad to go to Heaven but too good to go to Hell, unlike their portrayal today), was condemned to burn. On the morning of 28 May 1588, in front of a baying crowd, she was tied to a stake on Witch Hill before the timber beneath her feet was lit, with the only mercy being that she was garrotted before the fire took hold.

The exact number of people who suffered at Witch Hill is not known. There are several other reported witch trials relating to people from the town, and witches from the surrounding towns and villages were also brought to St Andrews to be executed. The killings at St Andrews were not, however, restricted to accused witches. In 1563, under the watchful gaze of Mary, Queen of Scots, a young French nobleman named Pierre du Chastelard approached the executioner's block. His crime was one of passion for the queen, a love that he mistakenly thought she shared. He had become one of the queen's most trusted companions when she had stayed with one of the principal families of France and had returned with her to Scotland. The budding poet wrote for her, and he took her enjoyment at reading his poems as confirmation of the growing affection between them. While travelling from Edinburgh to St Andrews, the queen stayed overnight at Rossend Castle in Burntisland.

Shortly after she had retired to her bedchamber, the castle was filled with her screams and those of her ladies-in-waiting. Her guards ran to her assistance and it was found that Chastelard had been hiding in the room, hoping to be alone with the queen. It transpired that three weeks earlier, while the queen prepared for bed at Holyrood Palace in Edinburgh, her dog started barking at the bed. It was found that Chastelard was hiding underneath. The queen forgave him that time, but on this occasion, he was taken to St Andrews to stand trial.

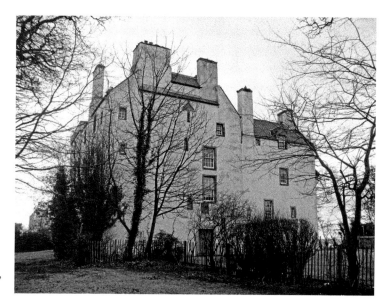

Rossend Castle, Burntisland.

A week after the incident, in front of a large crowd, he looked to where the queen sat and called out 'Adieu, loveliest and most cruel of princesses', before bowing and placing his head on the block. It would appear Mary still held some affection for him, as she is reported needed comforting as the executioner's axe fell.

For high-profile cases, a special instrument of execution, known as the Maiden, was called in rather than use of the common executioner's axe. While many people think the guillotine was first used during the French Revolution, the Scots were, in fact, using an early version of it as early as 150 years before this. First used in 1564, the Maiden consisted of an oak frame around 3 metres in height, with a distance of just under a metre between the uprights. A wide footplate provided stability at the sides, while a brace stabilised it at the rear. Between the two upright posts, a sharpened sheet of iron faced with steel sat, with a massive lead weight above. The weight was attached to a pulley system, allowing the blade, which was guided by grooves in the upright, to be hoisted. The victims placed their head on an executioner's block below, and the rope was released, allowing gravity to do its job. This was generally deemed a humane method of execution as it was intended to remove the head in a swift, single motion, unlike the executioner's axe, which always had an element of human error with the executioner sometimes missing the neck or needing a few chops to get all the way through. The Maiden travelled all over Scotland and was in use up until 1708, by which time it is estimated that it had been used to execute 150 people.

One of the most notable uses of the Maiden was in St Andrews in 1646 when Sir Robert Spottiswood was beheaded with the device. Sir Robert was a prominent lawyer, who had worked his way through the ranks to become the President of the Court of Session and Secretary of State for Scotland. He was also the son of John Spottiswood, the Archbishop of St Andrews. The circumstances that led up to his execution related back to 24 July 1567, when James VI of Scotland had been proclaimed James I of England, bringing together the crowns of Scotland and England. The same king now had two countries with differing religions to deal with, as well as a Catholic uprising that had started in England while his mother Mary, Queen of Scots, had been imprisoned there. Having established an agreement in England, James attempted to bring the Scottish Church in line, as far as possible, with that in England. This was opposed by many, and an uprising of a religious faction known as the Covenanters commenced. The Covenanters supported the reformed Protestant church and opposed the changes the king was trying to forcibly introduce. The result was decades of war between the Covenanter and the Royalist armies. Sir Robert Spottiswood was a Royalist and fought in several battles against the Covenanters. He joined the Marquess of Montrose in the Royalist army against the Covenanters at the Battle of Philiphaugh on the 13 September 1645, which ended with a decisive win for the Covenanters. Sir Robert was captured and initially taken to Glasgow before being moved to St Andrews to stand trial, which took place in the Parliament Hall at St Andrews University. Having been found guilty, he was condemned to death, and the Maiden was sent for from Dundee. On the morning of 16 January 1646, he was led to the market cross, where the execution was to take place. He walked to his death in a dignified manner and, knowing he was not to be allowed to address the waiting crowd, he had arranged for his final words to be printed, which he handed out as he went. Having placed his head on

the block, it was swiftly and cleanly removed by the plunging blade. He was just another victim of the battles between religion and the monarchy, or religion against religion. It is perhaps not surprising that St Andrews holds the unenviable title of the place where more killings in the name of religion took place than anywhere else in the country.

DID YOU KNOW?

A common punishment for minor crimes was to have your ear mutilated. A jailer would escort those convicted to the market square in St Andrews before dawn, where a number of posts stood. Having been forced to stand on a stump of wood, their ear would be nailed to the post. They had a choice of ripping themselves away, or facing a day of humiliation, after which the jailer would kick the stump away from under them, ripping their ear!

7. Rebirth of the City

In 1558, Walter Mill, a priest from the Parish of Lunan near Montrose, was brought to St Andrews. His crime was, at the age of eighty years old, he had become too infirm to perform Mass. The accusation had been made that this was a clear sign that he had sympathies towards the heretics. He was so frail he was unable to walk to his place of execution and had to be supported by the prison guards. After centuries of killing in the town, this was the final straw for the townsfolk. Walter Mill was the final person executed in the town on an accusation of heresy. The end of such a violent period should have brought renewed hope to the town, but it continued to decline. Without religion pulling people through the city gates, there were not enough customers for many of the businesses to survive. With fewer businesses, there were fewer jobs and less money, forcing people to leave the town to seek work. Less people in the town meant even less customers for the surviving businesses, and the downwards spiral continued. In 1697, there was another attempt to move the university to Perth. In the argument for the move, it acknowledged that while St Andrews had once been a city of high rank, it was falling into obscurity, having never recovered from the Reformation, and would soon be nothing more than a small fishing village. Fortunately, the move failed; otherwise, that analysis of the future of the town would have probably been correct.

Fishing was the only viable industry that remained, and as a result when the old wooden pier at the harbour were destroyed in a storm in 1655, there was a determined effort to rebuild it, using stones from the cathedral and castle ruins. The hope was this would keep the fishing boats working, but that was not to be the case, and a series of

St Andrews Harbour.

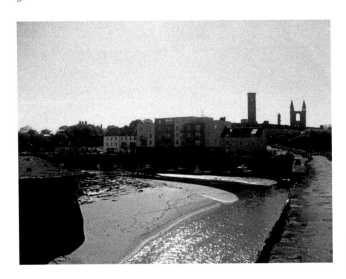

Entrance to St Andrews harbour.

storms over the coming decades almost wiped out the fishing fleet. Most people who remained in the town lived in buildings that were little more than slums. St Andrews in the late seventeenth and early eighteenth century would be unrecognisable to anyone who knows the city today.

In 1754, everything started to change, when events among the university students went on to lead to the new fortunes falling on the city. This was the year that the last archery competition for the Silver Arrow was held. It was also the year that twenty-two Noblemen and gentlemen formed the Society of St Andrews Golfers. A Silver club was made, with St Andrew engraved on the head, and a competition set for 14 May to be played annually for the club. The winner would earn the right to hang a silver ball from the club. Effectively, the Silver Arrow competition had been replaced by the Silver Club competition; some of the initial members were, in fact, previous winners of the Silver Arrow. The main difference with the Silver Club competition was, rather than competitors being restricted, it was open to 'Noblemen or Gentlemen or Other Golfers from any part of Great Britain or Ireland', with each one paying five shillings to enter. It was an attempt to lure people back to the town, ideally people with a bit of money, all of whom would stay in St Andrews, and eat and drink there. And it worked.

The Treaty of the Union that brought Scotland together with England had opened up the doors of the British Empire to Scottish businesses, and land values started to increase around the same time due to another revolution, an agricultural one this time. There was

DID YOU KNOW?

According to local tradition, when the pier was rebuilt the work was apparently carried out by Dutch women.

more money in the country and the new golf competition brought people who wanted to spend money to St Andrews. The surviving grand houses in St Andrews could be bought for less than comparable properties in the likes of Edinburgh, encouraging those who visited to set down roots in the town. The Revd Dr Andrew Bell, who was born in St Andrews in 1753 and had been educated at the university, returned to the town from India in 1797. While in India, he had been the chaplain to the East India Company in Madras. While there, he had developed a new teaching method for the orphaned children of soldiers, where part of the process was they would help each other. The method was successful and when he returned he was keen to bring it to Britain. By 1833, 10,000 schools were using his system, and he gave St Andrews £10,000 to introduce the method to the town and a further £50,000 trust to establish Madras College, named after the area of India in which he had worked. Madras College itself, which remains a school today, attracted families to the town.

With investment coming back into the city, the university buildings that had fallen into decline could once again be restored. The colleges of St Salvator and St Leonard had already merged, and extensive work was carried out to St Salvator's Chapel between 1760 and 1770, including the replacement of the roof. The original roof had in fact been stone, and it is said that when it was deliberately brought down, the whole town shook.

Madras College.

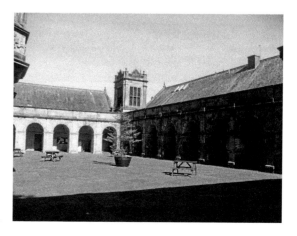

Madras College quadrangle.

The growth of golf not only brought demand for places to stay, eat and drink (it is estimated that by the end of the 1750s, St Andrews already had over forty alehouses), but new employment opportunities as caddies. Locals who knew the golf course well were paid by visiting golfers to carry their clubs and offer their advice. Perhaps as a sign of the wealth of many of the golfers, in 1771, it was ruled that any man caught tipping a caddie more than six pence would be fined two bottles of claret by the St Andrews Golfers Society. On 28 May 1773, the annual Silver Club competition was limited to members of the St Andrews Society and the Leith Society (now known as the Honourable Company of Edinburgh Golfers, based at Muirfield), which no doubt gave both clubs a boost in membership and revenue.

In 1834, the Society of St Andrews Golfers would go on to become the Royal and Ancient Golf Club, the governing body of golf, when William IV became the patron. The foundation stone for the world-famous Royal and Ancient clubhouse, which sits in front of the first tee and is the most photographed building in the golfing world, was laid on 13 July 1853. Prior to this, the members met at Baillie Glass's Inn, where the DIY store now stands on South Street.

The Royal and Ancient created the rules for golf, one of which was to standardise the number of holes at eighteen, which meant the course at St Andrews, which had twenty-two holes, needed to be altered.

The Royal and Ancient Clubhouse.

DID YOU KNOW?

The Old Course has 112 bunkers, with each individually named. In the 2000 Open Golf Championship, Tiger Woods managed to avoid every bunker and won by eight strokes.

The first tee and eighteenth green of the Old Course.

With the popularity of golf in St Andrews showing no signs of slowing down, steps were taken to preserve the course. At that time, the sea came right up to almost the edge of the course and close to the Royal and Ancient Golf Club. The process of land reclamation started, in what would seem a strange way by today's standards. One example is the method of George Bruce, a town councillor, builder and poet. To secure the land around the first tee, four old fishing boats were placed, in a row front to back (or bow to stern), in the shallows to mark the outer edge of the land to be reclaimed. They were filled with rocks to keep them settled on the sand, and the landside was filled with soil. Although the boats had to be reset several times, the method was ultimately successful in holding back the waves and, although the method has been updated, this area, still named the Bruce Embankment, is where a car park and the British Golf Museum now sit.

The Bruce Embankment.

Religion ultimately also played a part in bringing tourists back to St Andrews. Restoration work had started to reveal the hiding places of artefacts thought lost in the devastation of the Reformation. While carrying out work on Bishop Kennedy's tomb in St Salvator's Chapel, three of the university's maces were found. Sections of a statue of Bishop Wardlaw, the founder of the university, were also discovered – the head had been hidden within the cathedral wall, while it was found that the body had been concealed in a house on South Street, where it had been inserted as a window lintel. The final surviving piece was the plaque, which had been used as a paving stone in South Street. In the second half of the nineteenth century, there was a realisation that the ruins of the cathedral and castle, with their centuries of history, could offer attractions for visitors to the town. The problem was that both sites had suffered centuries of neglect and quarrying and had become dumping grounds. Work started on removing the rubble and rubbish

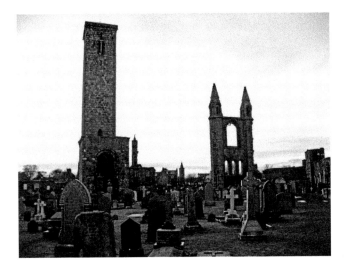

A view of the cathedral.

Burial cists uncovered during ground-levelling work.

from around the remains, and with the ground being lowered by as much as a metre in certain areas before the original levels were found, a squad of stonemasons worked relentlessly repointing the newly exposed walls.

With a railway line linking St Andrews to the mainline between Edinburgh and Dundee, making travelling to the town easier, the recovery of the town was secure.

The Tom Morris Story

Tom Morris is a golfing icon worldwide, yet while many know his name, the full extent of his involvement, not just as a player but also as a club maker, ball maker and course designer is less known.

Born in St Andrews on 16 June 1821, the game of golf soon attracted his attention. When he was fourteen years old, he started an apprenticeship at a shop owned by Allan Robertson, one of the world's first professional golf players, making clubs and balls. Having completed his apprenticeship, Tom continued to work for Robertson until, in 1851, Tom took up a post at a new club in Prestwick, where he designed and maintained the course, as well as made equipment and offering tuition. He was also heavily involved in the creation of the Open Golf Championship, which was first played at Prestwick on 17 October 1860 with Tom striking the first shot.

In 1865, at the request of the Royal and Ancient Club, he returned to St Andrews to take up the position of golf professional and greenkeeper. He found the course to be in an overall poor condition, and he set about using the knowledge he had gained at Prestwick to redesign the course, widening the fairways, improving the greens and adding new greens to the first and eighteenth hole. Tom had married a lady named Agnes Bayne in

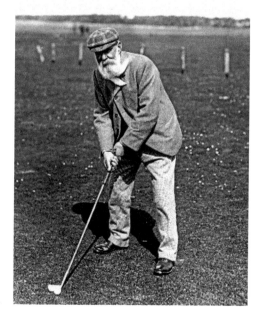

Old Tom Morris.

Tom Morris's home.

Tom Morris's shop.

1844, and they set up a family home in St Andrews, where he established a shop on the Links making balls and clubs.

Together, they had five children, all of whom sadly passed during Tom's lifetime. The most tragic loss was possibly that of his son, also named Tom, born on 20 April 1851. Tom Jnr grew to be probably the most gifted player that golf has ever seen and, to avoid confusion with them both having the same name, Tom Snr became known as 'Old Tom', and Tom Jnr became known as 'Young Tom', or 'Tommy'. Old Tom went on to

win the Open Golf Championship in 1861, 1862, 1864 and 1867. His win in 1862 was by thirteen strokes, the largest margin of victory recorded, and his final win, at the age of forty-six years old, made him the oldest player to have ever won the competition. Tommy first competed in 1865 at fourteen years old, and he remains recorded as the youngest ever competitor. In 1868, at the age of just seventeen, Tommy won his first Open Golf Championship, making him the youngest ever winner, a record that still stands today. Old Tom also competed, and came second. Tommy would go on to win again in 1869, 1870 and 1872 (there was no competition in 1871), which would make him the first player ever to win four consecutive Open Golf Championships, another record that still stands. It was as a result of this success that the Claret Jug is the prize in the Open today. The trophy was initially a belt (known as the Challenge Belt), which the winner held for a year, but the rules stated that if a player was to win in three consecutive years, they were allowed to keep the belt. Tommy's 1870 win, therefore, secured his ownership of the belt, and in the year when there was no competition, it was agreed that Prestwick and St Andrews would share the competition as venues, and a new trophy, being the Claret Jug, was made. Tommy, of course, went on to be the first winner of that too, although the actual trophy was not ready in time for him to receive it.

With so many records between them, it is easy to imagine that when the father and son team played together in pairs competitions, they were almost unbeatable. On 4 September 1875, they were due to play in such a competition in North Berwick. Tommy had considered pulling out of the game, as his new wife, Margaret, was heavily pregnant and had been quite unwell. It is believed she persuaded him to go, and he set off by train with his father. During the match, a telegram was received either just before the end of the game or just after it ended. Depending on which version we go with, either

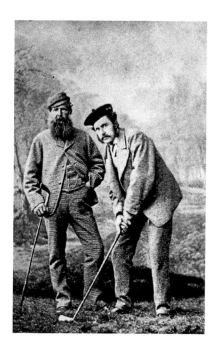

Old Tom Morris and Tommy.

the telegram was passed to Old Tom during the game and, when he read it, he found it was a request for Tommy to come home as Margaret had gone into labour. As the game was almost finished, and they would have to wait for some time for the next train, Old Tom did not tell Tommy the content of the telegram until after the game (which they won). In the alternative version, the telegram was handed directly to Tommy just after the game. Irrespective of which version is correct, a spectator heard about the news, and told Tommy he had a boat. He offered to sail them across the Forth to St Andrews, which would save them waiting for a train, and would be quicker than the train. They took him up on his offer, but when Tommy rushed home, he learned that both his wife and baby had died.

Tommy was distraught and grieved for several months, which affected his health. He never fully recovered and, on Christmas Day in the same year, Old Tom found Tommy dead in the family home. After this dreadful loss, Old Tom heard people comment that Tommy had died of a broken heart, and he was said to have responded the he did not believe that was the case, as it if was, he too would be dead. Tommy was buried at the cathedral graveyard, with many golf clubs donating money towards his impressive headstone.

Old Tom went on to devote the rest of his life to golf. He continued to work and was involved in the design of the New Course and the Jubilee Course at the end of the nineteenth century (after which the existing golf course adopted the name the Old Course, to differentiate itself from the other courses). In 1896, at the age of seventy-four, Old Tom became the oldest player ever to compete in the Open Championship, and he continued to work until his death in 1908, another tragedy when he fell down a flight of stairs in the New Golf Club and never recovered from his injuries.

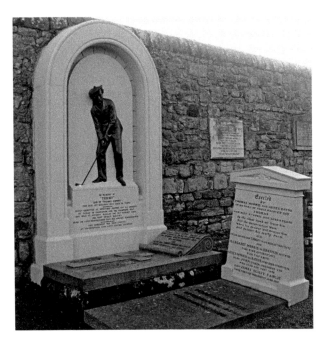

Tommy's grave.

TOM MORRIS 1821-1908

OLD TOM WON THE OPEN
FOUR TIMES (1861-62, 1864, 1867),
A FEAT MATCHED BY HIS SON,
TOMMY (1868-70, 1872).
THE FATHER OF MODERN
GREEN-KEEPING, HE WAS KEEPER
OF THE GREEN AT PRESTWICK
AND AT ST ANDREWS (1864-1903);
A PIONEER OF PROFESSIONAL
GOLF; AND A PROLIFIC GOLF
COURSE DESIGNER.
"THE GRAND OLD MAN OF GOLF"
WAS INSTRUMENTAL IN THE
FOUNDATION OF THE NEW GOLF
CLUB (1902) AND WAS ITS FIRST
HONORARY MEMBER. A REGULAR
VISITOR, HE DIED ON 24TH MAY
SHORTLY AFTER A TRAGIC FALL
IN THIS CLUBHOUSE.
FATHER AND SON ARE BURIED IN
ST ANDREWS CATHEDRAL.

The plaque outside the
New Golf Club.

DID YOU KNOW?

The R&A hold a fictional competition to select their captain. The new captain is actually selected beforehand by the members, and then takes part in a golf match where he is the only player. After the first drive, he is declared as the winner. The caddie who collects the ball is awarded a sovereign. The only captain refusing to play was, reputedly General Eisenhower in 1946, who was concerned for the safety of the crowds.

8. Dean Linskill and the Secret Underground

For centuries, tales of a labyrinth of secret tunnels below the streets of St Andrews have circulated, and with the history of St Andrews, the idea is relatively plausible. Archbishops may have required to move secretly between the castle and cathedral when under attack. The New Inns was designed to be a royal residence, and a secret escape route may have been incorporated. With the close proximity of the sea, some believed there would be hidden tunnels to allow those in power to escape to waiting boats.

Possibly, the first of such tunnels found was accessed via a small, triangular cave that sat just above the high tide line between the current Sea Life Centre and the castle. To reach the entrance, it was necessary to climb the cliff at low tide when the rocks were exposed. Rumours circulated about this place and some believed it was just a sea cave. Others believed it was an escape tunnel, and that a boat would have been tied to the rocks, but all believed it was a fearful place, leading to few daring to explore it. Fortunately, those who did face their fears were able to give a description of what lay within. The small entrance was deceptive. After having to stoop for a short while, the tunnel soon opened out to be large enough for a person to walk upright. The tunnel sloped steeply down for around 15 metres, before levelling out and continuing for a further 21 metres, before opening up into a large chamber, which had two further tunnels leading off from it. Between the entrances to these two tunnels, a cross was carved into the stone, leading to the assumption that that chamber had been used for some undocumented religious reasons. It seems no one braved continuing further into one of the other tunnels, or if they did, they did not record what they found. The tunnel system has a traditional tale attached to it that a piper entered, playing his pipes as he went along, allowing those above ground to follow his progress. In this case, it is said that the pipes were heard to reach Market Street before falling silent, with the piper never to be seen again. Sadly, as a result of coastal erosion and later strengthening work to preserve the cliffs, the entrance to the cave has been long lost.

Further along the cliffs, between the castle and the harbour, another curious cave once existed. Again, this lay above the high-tide mark, and it caught the attention of a local noble woman named Agnes Stuart, better known as Lady Buchanan due to her marriage to Henry David Erskine, 10th Earl of Buchanan. They moved to St Andrews in 1760, along with their son, Thomas Erskine (a future Lord Chancellor), due to him attending university in the town. Lady Buchanan was known to be self-motivated and determined and had a slightly eccentric side, but few could have imagined what she planned for this cave. She arranged for a staircase to be cut into the cliff, along with a ledge that could be walked across to give access to the cave, and for work to be carried out to create two chambers, with a door between them within. The entire inner walls of the chambers were decorated with seashells and this was where she took guests for tea parties and to

entertain them, right up to her death in 1778. Sadly, the cave completely collapsed at the end of the nineteenth century, and the staircase and ledge have long been lost to erosion. Her reasons for picking it are not known, yet something drew her to it. Whether she knew something about the cave that no one else did and whether the seashells concealed other clues will never be known. Many people have speculated that this cave, which was shown on maps as 'Lady Buchanan's Cave', was the cave that St Regulus and his crew sought shelter in when they first arrived.

Other than these tales, the potential of underground tunnels remained relatively unexplored, until a particularly interesting man named William T. Linskill became fascinated with them. Born in 1855, Linskill used to come to St Andrews as a child on holiday and became so fond of the town that he moved there permanently in the 1870s. He took lessons in golf from Young Tom Morris (Tommy) and was a member of the Royal and Ancient. In 1896, he became a town councillor, and later the dean of guild, a magistrate's position that gave him the authority and responsibility to monitor and supervise buildings and associated work within the town – a job perfectly suited for a man who was determined to solve the mystery of the tunnels.

Linskill effectively made it his life goal to find the tunnels that he long believed had existed. He not only wondered about escape routes from the prestigious buildings, but also what had happened to the cathedral treasures. The historical records are full of information on generous gifts bestowed on the cathedral and, as the head of the church, it would have held great wealth; yet, there are no records of what happened to it when

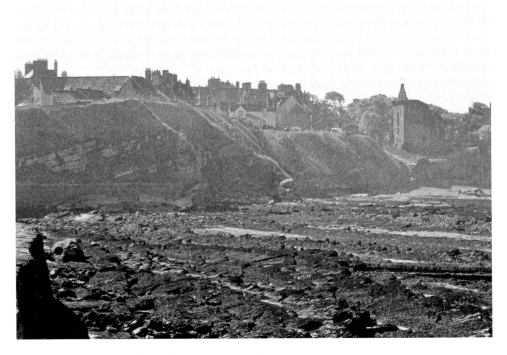

The cliffs where Lady Buchanan's cave was situated.

the buildings were ransacked during the Reformation. Had the riches been taken by the townsfolk, the town would have never fallen into the state it did. Linskill concluded that the only logical answer could be that there were underground treasure chambers that had not been discovered. His quest for the tunnels got an early boost when what at first appeared to be just that was found beneath the Pends Gateway. Investigations concluded that it was in fact a medieval culvert, but this just fuelled his determination. He took great interest in the works going on at the cathedral and castle clearing the grounds and was convinced that the entrance to the chambers would be found. It seems he was right. While carrying out the research for this book, I was fortunate enough to be able to read through his scrapbooks, which are held by the Special Collections unit at the university. These large books contain page after page of newspaper articles and witness statements telling about not only the discoveries of secret underground treasure rooms at other religious buildings all over the world, but more specifically of findings during the work at the cathedral. He received numerous reports from workmen relating to possible entrances to underground tunnels being discovered, yet much to his frustration, by the time word reached him, the site foremen had ordered for them to be filled in. This was no doubt done out of fear that any discoveries may hold up work, while using the convenience of ready-made places to dispose of some of the rubble rather than having to take it off site.

In 1879, he believed he had finally found proof when work being carried out at the castle to demolish the old castle keeper's cottage on the grounds uncovered a tunnel. According to newspaper accounts at the time, a workman was pushing his barrow when the ground below him gave way, resulting in both he and his barrow falling into an opening below. What was found was a tunnel that was largely blocked by debris. When cleared, it was discovered that the tunnel was roughly cut, sloping downwards for some distance before there was a drop into a much wider tunnel, and there were steps going back up. Unfortunately, the steps were blocked by the foundations of a house that had been built opposite the castle and, despite his best efforts, Linskill could not gain permission to open this up and explore further. Now known as the mine and counter-mine, this discovery proved that it was possible to cut tunnels in the ground below the city.

Undeterred, his work continued. Out of everything he searched for, the one thing the dean wanted to find the most was what he named 'the wee stair'. He had heard tales of a tight, narrow staircase being discovered at the cathedral during the ground levelling work and was completely convinced that this gave access to either the treasure vaults or the tunnel to the castle. It could also possibly give access to both. A newspaper article published in the *St Andrews Citizen* on 7 May 1927 states that Linskill met with one of the contractors, George Greig, who was working when the wee stair was first discovered in 1904. He was able to give the dean a detailed description of what was discovered and what happened. Greig told him that the steps had been found quite unexpectedly by Dr Gillespie and Dr Buist during the work. He stated that the stairs looked quite fresh, as though they had not been used very frequently and that there was a shaft that possibly was a ventilator that ran alongside the steps, covered at the top with a flagstone. The top two steps had been damaged at some point in time, although whether this was during the current work or earlier was not known. What amazed Mr Greig was the haste in which

Inside the mine.

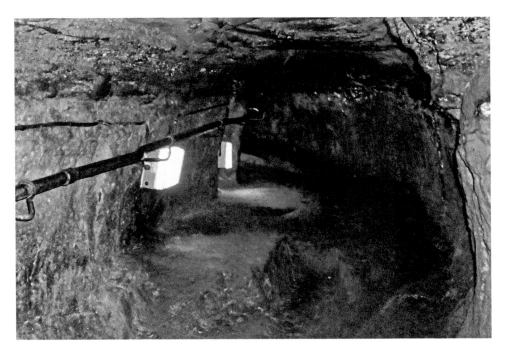

Inside the counter-mine.

all evidence was covered as, very soon after their discovery, a gravedigger named 'Scott' arrived and supervised while the staircase was being filled with tons of rubbish.

An account is also detailed in the scrapbook that Linskill states was given to him by Dr Lornie, a teacher at Madras College. In it, Dr Lornie claims that he saw the wee stairs, prior to them being filled in, and describes them as being well-preserved, and to have gone down very deep in a tight, narrow spiral. He and a couple of colleagues gathered some wood shavings, covered them in oil, lit them and threw them down the stairs hoping this would show how deep they were, but they went out of sight. One of his party ventured down as far as he dared, but as it was decided it was just a staircase leading to the beach, they were filled in. That statement alone I find quite staggering, as surely the question why there was a staircase leading to the beach would have been raised.

Linskill's persistent writing in the papers about the stairs prompted a number of responses of which I find one to be particularly interesting. In it, a correspondent states that he recalled work being carried out on the Bishop's Palace (a name sometimes used for the castle). On one occasion while passing it, he had stopped and spoken to one of the stonemasons about what work was being carried out, and he advised they were blocking up the passageway that leads to the cathedral. The reason this particular account caught my attention was not so much the nature of the work, but that it took place between 1864 and 1865, and was supervised by Mr Hall of the Department of Woods and Forest. He was the same Mr Hall who came up repeatedly in the story of the discoveries at the Haunted Tower. It seems to me that Mr Hall would have been able to give a lot of detail about the secret underground of St Andrews.

As years passed, it became clear from the tone of his correspondence that Linskill was becoming increasingly frustrated that the tunnels continually evaded him. He arranged for a number of digs in the streets of St Andrews to try to find some evidence. An explanation for the tunnels at the castle had been found. The tunnel coming from the landside towards the castle is believed to have been made in an attempt to get into the castle while it was being held by the murderers of Cardinal Beaton. Having learned of the attempt to tunnel in, those within the castle dug a counter-tunnel to intercept their enemy. Having had to do so by sound alone, a number of false starts were made, until eventually the counter-tunnel passed above the tunnel being dug. In doing so, the roof of the tunnel collapsed, joining the two at the point where it is described there was a drop. Linskill strongly disputed this, stating that if that was the case, the tunnel would have had to start at a considerable distance beyond where it is currently blocked as at that time, there were no buildings there. It would mean the tunnel was being dug in full view. He was provided descriptions of what lay behind the wall, which varied, but all stated that the tunnel did continue quite some distance towards the cathedral.

One article seems to bring everything together by someone who would have to have detailed knowledge of the supposed tunnel system. It stated that the entrance to what became known as the Piper's Cave was the main entrance to the underground network, which included tunnels to the castle and the cathedral. When either were under siege, supplies of food, water and ammunition could be brought in or, presumably as a last resort, people could escape through them. The same correspondent advised that the tunnel from the castle that had been discovered leads to a secret storage room below the

cathedral, where a number of valuable items are held, including a strong box that holds ancient manuscripts that would shed a lot of light on the early history of St Andrews.

Linskill continued with his attempt to find the tunnels right up to his death in 1929. I have to add that having spent some time looking through the massive amount of information contained within the scrapbooks held by the university, I feel he was correct in his theories.

The Scores Hotel, which sits above the Piper's Tunnel.

Linskill's grave in the cathedral.

DID YOU KNOW?

Dean Linskill was responsible for improving the street lighting around St Andrews and arranging summer entertainment for locals and visitors at the Bruce Embankment. He also founded Cambridge University Golf Club.

DID YOU KNOW?

Apparent man-made caves in the cliffs around St Andrews were once believed to be access tunnels to the underground network. Linskill, however, established that these were early exploratory diggings, looking for a coal seam.

DID YOU KNOW?

Linskill almost lost his life in the Tay Bridge disaster on 28 December 1879. He had been on the ill-fated train and his coach had not arrived at Leuchars to pick him up due to the storm. He decided to continue to Dundee, but at the last minute, his coach arrived. The Tay Bridge collapsed a short while later while the train was crossing, killing all on board.

9. The Mystery of the Haunted Tower

With such a long and grisly past, it is understandable that St Andrews has its fair share of ghost stories, the most famous of which is the White Lady, who is seen walking the walls of the cathedral and around one of the towers in the wall, leading it to be known as the Haunted Tower. However, the true story of discoveries within the tower is little known and far more interesting.

While carrying out the clearance work at the cathedral, newly exposed areas of wall required to be repointed. The walls around the Haunted Tower were one of the sections that required the attention of the stonemasons, and while carrying out the repointing, one of the stones gave way, revealing a chamber behind. What exactly happened afterwards has been somewhat lost, and a more flamboyant version of events was created as the story was passed down through generations. Through my research, I located a newspaper article published on 1 November 1894 in the *Evening Telegraph* that attempts to establish the facts. As the earliest investigative report I could find, it is likely to be the most accurate.

It starts out repeating an earlier, shorter article covering the discovery of the chamber and that the opening formed in the wall was just large enough for a man to crawl through. Curious as to what lay within, one of the stonemasons squeezed his way in, with just his feet remaining outside. It was then that the other masons realised he was no longer moving, and they grabbed his ankles and pulled him out. He had passed out. Another of the men crawled in to see what was inside, but also had to be pulled out and was found to be 'in a very ill way'. A professor from the United College was summoned, and he entered

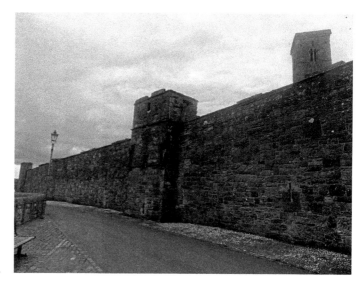

The Haunted Tower.

the vault completely, before emerging carrying the body of a young woman, wearing a long, white dress. The body showed no signs of decomposition, and the professor stated there were twelve bodies inside the chamber, all in a similar condition. The advice of the Lord Advocate was sought, and they were told to return the body, seal the chamber and to never talk about the events again. It is clear that even this early version has been exaggerated – if the opening was just wide enough for a man to crawl through, it is difficult to envisage the professor carrying a body out.

The news reporter then spoke to Mr Jesse Hall. Mr Hall was employed as a gas manager and representative of the Woods and Forest Department, responsible for overseeing the work. Initially, although he did confirm an unknown chamber had been found, he was dismissive, stating that there were bones inside that had been put there by maintenance workers rather than dispose of them correctly. Mr Hall's statement goes on to further conflict with that of the masons, as he stated that when the opening was created, it was found that there were a few steps inside leading to a blocked-up doorway. If this was the case, the masons could have only reached the stairs as there is no suggestion that they went ahead and created a second opening in the sealed doorway.

Mr Hall then provided him with a copy of notes taken by a local watchmaker named Mr Smith. He had heard the story of the chamber and, for some time, had been requesting access to it. Permission was granted and, on 7 September 1868, he and three colleagues, accompanied by a stonemason, knocked an opening in the sealed doorway. Going by Mr Hall's earlier account, this suggested that they had already passed through the first opening into the stair enclosure. The notes stated that by this time, the lower vault had been cleared, which presumably relates to the bones mentioned earlier. Perhaps it was the sight of these bones that had terrified the masons, rather than what lay within the chamber. Once inside, they discovered ten coffins, piled on top of one another, each

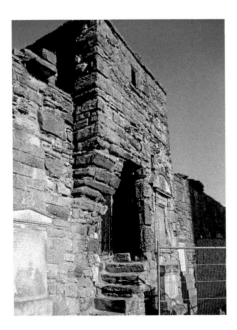

Stair of the Haunted Tower.

containing a well-preserved body. The most notable of the corpses was that of a young woman, dressed in white and wearing long white gloves. There was also what appeared to be a memorial stone inside the chamber, but it had deteriorated to a stage it could not be read. Once documenting the findings, the men left, and the mason again sealed the openings.

Mr Smith sought permission to re-enter the vault some time later, but Mr Hall had refused, stating that he 'did not care about it'. Eventually, he obtained permission and, along with a librarian from the university, named Mr Walker, he returned. On this occasion, only six coffins were documented, four still being in a pile but with two lying on the ground. Only one coffin was found to contain a body, that of a woman around four and a half feet tall with a mummified appearance. All that remained of the clothing was a decayed part of a white glove. How the coffins came to have moved, and what had happened to the missing coffins and bodies could not be answered.

Mr Smith continued to tell of a further occasion when he had accessed the chamber, this time accompanied by General Playfair, a member of a prominent local family. Accompanied by two others, they entered the chamber to find that it was empty. Mr Smith advised that the fact that there had been bodies found inside previously was not common knowledge, and so what had happened to them was a mystery.

The reporter moved on to interview Professor Heddle, who had been present when the chamber was opened in 1868. Initially, he said he could not recall much about the incident, which seems a strange response, as I am sure that discovering bodies inside a hidden chamber is something most people would remember! He did eventually recall that the vault was full of skulls that he had inspected and found them of far more interest than the 'nonsense' the reporter was there to discuss. There were some consistencies with the skulls – all had teeth in excellent condition, and all had signs of a disability, which would restrict the movement of the head. In addition, all had the jaw tied closed with a handkerchief and had been bleached using a method that was not known to have been used at that time. The reporter put it to him that these may have been the bones placed there by the maintenance worker, but he replied that there had only been skulls. When asked what had happened to them, he advised that they were to be placed in the museum, but Principle Sharp had objected, and so they were thrown over the cliff into the sea below.

The professor did then seem to recall entering the chamber, which he said was opened a few days later, giving a clear indication that the skulls were in the stairwell. Within the chamber, he stated, there were two coffins on the ground, one on the east side of the tower, and the other one on the west. The rest of the coffins had been stacked. Inside the coffin closest to him he saw a skeleton, and in another, he was able to reach inside and found another body there. When asked what had happened to the coffins and bodies, he replied that as far as he was aware, they were still there.

The last person the reporter spoke to was Mr D. Hay-Fleming. He had been present at a later opening that had been arranged by Linskill in 1888. On this occasion, the coffins were found to have mostly disintegrated, and bone fragments were scattered across the floor. Three coffins were on a trestle, and one contained the body of a well-preserved woman, wearing a long, white glove on one hand.

Inside the secret chamber.

It is clear that, even from these interviews with those directly involved, there is considerable variance in the stories. It is possible that the stonemasons who initially entered only saw the bones, or skulls, in the stairwell, which was enough to terrify them in the dark, airless room. The story of the professor then attending and bringing out the body probably relates to Professor Heddles' visit, but was added to the story to the initial discovery and somewhat exaggerated for effect. The varying number of coffins reported is potentially due to working in cramped conditions with little light; yet, the ever changing positions and stories of the bodies are more difficult to explain.

In 1894, Linskill later took it upon himself to send letters out to various newspapers addressing the rumours about the tower. He confirmed that he had entered the chamber in 1888 and that it had been found to be in a state of disarray. He also verified that one coffin contained the skeletal remains of a person dressed in satin that, when touched, became dust. She also wore a long, white glove. On this occasion, the stonemason who created the opening was named Grieve, who happened to be one of the stonemasons who first discovered the chamber in 1868, and he had commented to Linskill that the contents of the chamber looked quite different from how they were twenty years earlier. Linskill concluded that the chamber must have been accessed a number of times between 1868 and 1888, in addition to those documented, and the coffins and bodies tampered with. This is a logical conclusion, but the question remains who could do that as it is not an easy task to get in and out unnoticed.

Further research found an earlier report that may shed some light on the story. The *Dundee Courier* carried a report on 3 July 1861, seven years prior to the supposed first discovery of the chamber. The report states that stonemasons working on the outer wall

of the cathedral had found a continuation of the staircase in the tower behind the wall. They had gone inside and followed the stairs to find it led to a burial chamber, inside which there were several, well-preserved bodies. Work was stopped immediately and the Department of Woods and Forests were contacted. The instructions were given to seal the burial chamber and continue with the work. Interestingly, in what seems to be the first discovery of the bodies, the person who supervised the work was none other than a 'Mr Hall'. It is entirely probable that this was Mr Jesse Hall, who seemed to have had knowledge of the blocked-up doorway in the stairwell, even though the masons who had entered earlier had only got as far as the stairwell. It may also explain his later reluctance to have the chamber opened when it was rediscovered in 1868, as he knew what it contained. It seems Mr Hall, and the authorities at the Department of Woods and Forests, knew more about the bodies in the chamber than was acknowledged, and they were the only people who would later be able to enter the tomb unnoticed by others.

What happened to the bodies will never be known, but their discovery did provide some answers about the ghost stories. The question of the identity of the white lady, or more specifically the body in the chamber, has however remained a mystery. There has been a lot of speculation, with suggestions that the bodies were from plague victims, or Pictish royalty whose remains were those that were placed there when the cathedral was built, or even one of Mary, Queen of Scots' ladies-in-waiting. The most plausible answer I have found, based on the research I have carried out, can be found in the aforementioned book, *The Knights of St John*, by David Henry. The author makes some observations about the tower, the main one that it is the only one in the cathedral wall that is square; all the

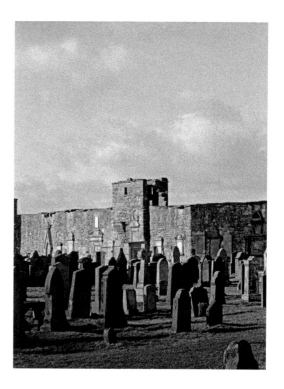

The general position of the Haunted Tower.

rest are circular. It was also estimated that the stone walls are only around 430 millimetres thick, despite most houses built during the same period having walls over 1 metre thick. The small dimensions of the rooms, the odd shape and the thin walls led the author to conclude that this particular tower was, in fact, a summer lounge, or garden house, for the priors of the cathedral to sit in peace.

The book then goes on to note a strong connection between the bishops of the cathedral and the Martine family, a wealthy local family. The Martine's connection with the church dated back to Thomas Martine selling his house to the bishop when ground was needed for the construction of St Salvator's College and, since then, family members had occupied many senior positions for both the church and the state. A carved memorial plaque on the outer wall of the Haunted Tower gives clues as to its purpose. It bears three shields and, although the outer ones were noted to be too badly worn to read, the one in the centre, at least at the start of the twentieth century, had survived sufficiently for some of it to be deciphered. The shield depicts the Lion Rampant, the sign of the Clephane family of Carslogie, along with the letter 'K' on one side, and 'C' on the other. Below the shield was the date 1609. The style is almost identical to a memorial very close to the tower, which bears the three shields of three families, with the squires' initials above, and the dames initials at the sides. This is also dated 1609 and so gives a clear indication if the purpose of the shields and letters as identifiers.

In 1567, John Martine, 16th Earl of Denbrae, married Katherine Clephane of Carslogie. The marriage was happy, and they had three children together, but Katherine's brother was continuously on the wrong side of the law, and John Martine ended up having to sell his estate at Denbrae to pay his legal costs. Katherine died when she was still relatively young, although the exact date is not known, and John Martine died in 1608. Following his death, his son, who had become wealthy in his own right, inherited his father's titles and bought the estate of Denbrae back for the family. It is believed that Martine's daughters died of the plague in 1605.

It is suggested that the family had used their connections with the bishop to use his old summer room as a makeshift mausoleum during the plague years (by this time the Reformation was underway and the cathedral extensively damaged). The clues from the inscription link it to the Clephane family through the shield, and specifically Katherine Clephane through the initials. Based on the identical monument, John Martine's initials would have been above the shield, but these had been eroded away. The final clue is the date, with Katherine passing first, followed by John in 1608; it is likely they both would have been laid to rest in the same mausoleum as their daughters. With their son stepping in and restoring the families estates, it is though the went ahead to have a memorial plaque made for his parents, and with the town still in religious turmoil, opted to have the tower sealed, and the plaque added.

A lot of this conclusion may be based on assumptions, although the strongest clue is the shield and initials. It is likely that it was only ever meant to be a temporary tomb, with the intention to move the bodies at a later date, but time took its toll and they remained.

So there we have it, the body of the lady in the white dress, and the ghost of the White Lady, is Katherine Clephane ... or is she?

DID YOU KNOW?

There have been tales of sightings of the White Lady in St Andrews cathedral for over 200 years, making hers the oldest, most consistent ghost story in the town.

DID YOU KNOW?

There are other incidents of bodies being stored at the cathedral. In February 1848, Mr Young, an English teacher at Madras College, had the body of his wife dug up from the cathedral cemetery, where she had been buried seven weeks earlier. For an unknown reason, he wanted the body moved to Edinburgh and it was stored in St Rule's Tower until such time as the arrangements could be made.

10. The City Today

St Andrews today is a beautiful city, with a mix of buildings that range from medieval to modern.

It is difficult to imagine that the town once was nothing but forest and swamps, or the sense of excitement and hope at the construction of the cathedral and castle, and the destructive violence that followed. We can only be grateful that so many of the buildings survived the decline of the town, some of which have gone on to become among the most expensive properties in the country. But there are reminders of the city's past throughout, you just need to know where to look.

Plaques on the front and back of the New Golf Club commemorate the achievements of Old Tom Morris and his unfortunate death. Old Tom's workshop where he made and sold golf clubs and balls still remains, overlooking the first tee and eighteenth green of the Old Course, both designed by Tom. A plaque at his house on Links Crescent also remembers this great man, and the graves of both old and young Tom bring thousands of people to the cemetery at the cathedral. The most photographed grave is actually that of Young Tom, with a fine statute of him playing golf. Many visitors do not notice the modest headstone of Old Tom, laid to rest beside his son and family.

The needle-shaped Martyrs' Monument at Bow Butts commemorates some of those executed during the start of the Reformation, an acknowledgement of the wrongs of many centuries ago, and the letters 'GW' and 'PH' mark the spots where George Wishart and Patrick Hamilton suffered their horrific deaths.

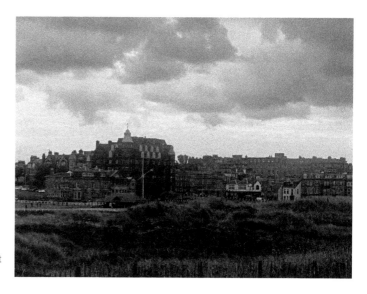

St Andrews from the West Sands.

Old Tom Morris's grave.

The Martyrs' Monument.

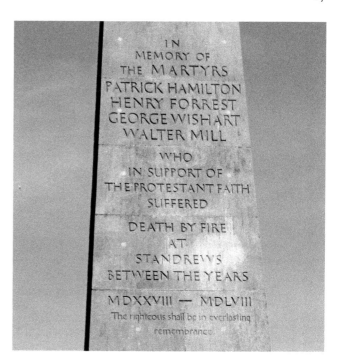

IN
MEMORY OF
THE MARTYRS
PATRICK HAMILTON
HENRY FORREST
GEORGE WISHART
WALTER MILL

WHO
IN SUPPORT OF
THE PROTESTANT FAITH
SUFFERED

DEATH BY FIRE
AT
ST ANDREWS
BETWEEN THE YEARS

MDXXVIII — MDLVIII
The righteous shall be in everlasting
remembrance

Inscription on the
Martyrs' Monument.

Watch as students swerve to avoid walking across the mark for Patrick Hamilton; it has long been believed to be a curse for new students to step on the letters and, any who do, will not graduate successfully. The only way to rid yourself of the curse is to take part in the May Day Dip, which is a tradition where students go for a swim from the beaches of St Andrews in the early morning of the May Day holiday. If you spot students doing a merry dance upon the letters, they are likely to be senior students who have just graduated. This act is not out of disrespect to Patrick Hamilton but is a celebration of defeating the curse.

The ruins of the castle and cathedral can be explored, and the brave can venture into the mine and counter-mine. You enter from the castle into the counter-mine, a narrow, damp passageway that requires you to almost crawl in parts. A metal ladder then takes you down to the mine, which is far bigger, and you can follow the steps up to where it is blocked off. Imagine what was going through Linskill's mind when he first gained access and ask yourself whether he may have been correct in his theories. Would someone digging a tunnel for siege warfare really take the time to make it large enough for two or three men to walk upright, side by side? Would they go to the effort of cutting a perfect staircase within it? Or were they simply clearing an old, existing tunnel? Could those inside the castle really have found and intercepted the mine by sound alone? Or did they have knowledge of roughly where an existing tunnel was? I do believe that Linskill was correct; yet, he faced the same obstacles as those before him had faced exploring the Haunted Tower and wee stair. In addition, I located a historical record, written in 1390 by Andrew Wyntoun, one of the most respected Scottish historians, in which he states that at that time, there was a silver case that contained copies of the gospel from the

first century. This case was kept at the north end of the high altar of the cathedral church. Could this be the box containing documents providing details on the early history of St Andrews that Linskill was told about over 500 years later?

The brass line, which marked the Gregorian meridian line, can be viewed on South Street outside Parliament Hall, so called because the Scottish Parliament was moved to this building when the plague struck Edinburgh. In the gardens behind stands a statue of Bishop Wardlaw, based on the pieces found in the cathedral wall, St Salvator's chapel and South Street. Visit the Museum of the University of St Andrews on the Links, and you can view the three maces of the original colleges and the recovered early silver arrows.

St Andrews has not yet revealed all of its secrets of the past. In 1895, workmen carrying out repairs to a house on Bakers Lane removed what they believed to be a section of roughcasting that was coming away from the wall. Instead, they found below a small carved face, with hideous features. This is believed to depict Pontius Pilate, the Roman governor who oversaw the trial of Jesus Christ and sentenced him to death by crucifixion. This was believed to date back to when the property was used by the Knights of St John and, in 1939, when the building was being demolished, Mr T. T. Fordyce granted permission for it to be moved to the gable end of his property that faces into a garden area on Bakers Lane, known as St John's Garden. The face remains today, although it is badly weathered and no features can be seen.

Between 1904 and 1906, parts of the cliff face at Witch Hill collapsed due to coastal erosion. These collapses revealed bones and skeletons, some believed to be at least 400 years old. On 24 June 1946, the *Dundee Courier* reported that the Piper's Tunnel may

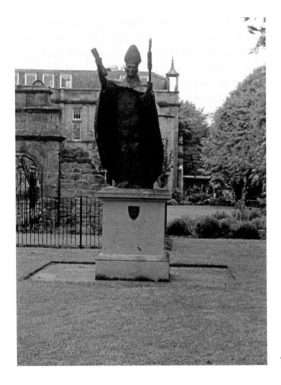

The statue of Bishop Wardlaw.

The early silver arrows.

have been found. The article says that during alteration work at the James Mackenzie Clinical Institute (now the Scores Hotel), workmen had accidentally uncovered a tunnel in the basement cellar at the front of the building. They stated that the tunnel, which was partly cut through the rock and partly built up stone, travelled north towards the sea. It had collapsed a short distance in. They also believed that the tunnel continued in the opposite direction and that the basement of the building had effectively cut through the tunnel. An application was made by Captain Douglas Percival, who was overseeing the work, to open up the tunnel to see where it went, but it seems he had the same lack of success as Linskill, as there are no records of this being done.

In 1964, while work was being carried out to the Star Hotel, which once stood beside the Holy Trinity Church, three skeletons were disturbed. Several others were also seen but were undisturbed. In 1982, there were further reports of more skeletons being found during roadworks, and in 1989, trial excavations for pedestrianising the area revealed more bones, resulting in a redesign of the proposals. Further excavations were carried out between September and October 1991 for the local authority, and over 100 complete skeletons along with the bones of many more were uncovered. It was clear that the church once had a large graveyard, which had since been built on top of. More remains were found below South Street, and between July and August 2003, a further seventy complete skeletons were found during excavations while the library was being refurbished. In March 2012, resurfacing work at Greyfriars Garden came to an abrupt halt when skeletons were found just a few inches below the road surface. Archaeologists believe that these were connected to the Greyfriars Chapel that once stood nearby but was completely destroyed in the Reformation. It is sometimes said by local archaeologists that if you dig anywhere in St Andrews town centre, you will find human remains; yet, they

are not only restricted to the town centre. During excavations on a site known as Hallow Hill, twenty bodies were discovered in long, stone (cists), along with Roman artefacts. Between 1975 and 1977, St Andrews had grown considerably and new houses were being built in the area and over 150 additional burial cists, dating back to the seventh century, were found. A small number of these burial cists were left uncovered as a representation of what was found, but few realise how many remain, reburied below this popular area for recreation. In addition, there have long been stories that the eighteenth green on the Old Course is raised because it was formed over a burial mound.

St Andrews truly is a unique small city. I know of nowhere else where, rather than having a large campus, the university buildings are part of the town, with departments and lecture theatres sitting in ancient buildings beside shops and houses. It is also the only town I know of where locals and visitors mingle with the rich and famous, and even royalty, with no great fuss. As you walk around the town, keep your eyes open, you never know who you may spot sitting at one of the street cafés or tucking into an ice cream.

One of the skeletons at Greyfriars Garden.

The burial cists at Hallow Hill.

The face of Pontius Pilate.

DID YOU KNOW?

St Andrews has what is known as the 'three people rule'. That is, if you walk through the town centre, you are likely to know one in three of the people you pass.

DID YOU KNOW?

St Andrews welcomes around 7,000 new students every year and up to 200,000 tourists.

Author's Note

St Andrews is my hometown. It is where I was born and raised and where most of my family still live. I first became interested in the history of the town as a child, when my grandfather, who was a painter, artist and gold leaf expert, used to tell me tales of the buildings he was working in. My initial interest was in the paranormal side, just like any wee boy, but being told a place was haunted was never enough for me, I wanted to know who haunted it, why and what happened. A natural progression was on to the history of buildings to discover the past, which uncovered a lot of long forgotten stories that were not suitable for a paranormal book – there were no ghost stories attached but are stories worth recalling to give some unknown historical context to places. What I have found is that the truth behind many locations is often more interesting than any resultant ghost story.

I do hope you have enjoyed the book and I welcome any feedback or additional information anyone may have. You can contact me through my website at www.gstewartauthor.com or find me on Facebook at Gregor Stewart, Author and Paranormal Researcher.

References

Publications

Anon, *A Vindication of the Church of Scotland* (London: 1691).

Anon, *The History of the Kingdom of Scotland* (London: 1695).

Anon, *The Life of George Wishart* (Glasgow, N.D.).

Anon, *Votiva Tabella* (St Andrews University: 1901).

Cumming, J.; Fox, J., *Fox's Book of Martyrs* (George Virtue, London: 1844).

Grierson, J., *Delineations of St Andrews* (Peter Hill, Edinburgh: 1807).

Grierson, James, *St Andrews As It Was and As It Is* (G.S. Tullis, Cupar: 1838).

Henry, David, *The Knights of St John* (W C Henderson & Son, St Andrews: 1912).

Leach, Hendry, *The Happy Golfer* (MacMillan and Co: 1914).

Leighton, J.; Stewart, J.; Swan, J., *History of the County of Fife* (Joseph Swan, Glasgow: 1840).

Lyon, Revd C. J., *History of St. Andrews: Episcopal, Monastic, Academic, and Civil* (William Tait, Edinburgh: 1848).

Martine, George, *Reliquiae Divi Andreae* (James Morrison, St Andrews: 1797).

Rogers, Charles, *History of St Andrews* (Adam and Charles Black, Edinburgh: 1849).

Ruter, Martin, *The Martyrs, or a History of Persecution* (R. Robins, Cincinnati: 1830).

Woolf, Alex, *From Pictland to Alba* (Edinburgh University Press: 2007).

Wynd, Alexander, *History of the Parish Church of the Holy Trinity St Andrews* (Lulu Publishing: 2012).

Wyntoun, Andrew, *The Original Chronical of Scotland* (Edinburgh: 1872).

Young, Douglas, *St Andrews, Town & Gown, Royal & Ancient* (Cassell, London: 1969).

Websites

The Survey of Scottish Witchcraft: http://www.shca.ed.ac.uk/Research/witches/

University of St Andrews: https://www.st-andrews.ac.uk/

Also available from Amberley Publishing

ST ANDREWS

THE POSTCARD COLLECTION

HELEN COOK

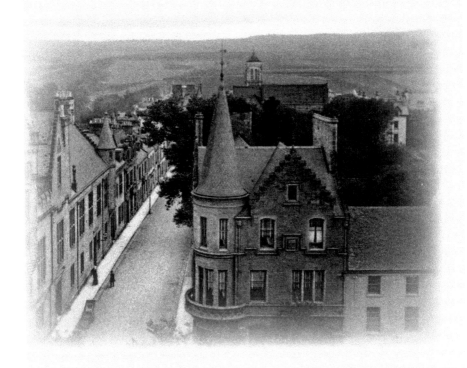

ISBN 978-1-4456-4576-6

Available to order direct at www.amberley-books.com
or call 01453 847 800